Visual Elements of Art and Design

Frederick Palmer

Longman

London and New York

Longman Group UK

Limited,
House, Burnt Mill, Harlow,
Essex CM20 2JE, England
and Associated Companies throughout the world.

First published 1989

Set in 11/13 point Bembo, Linotron 202

Produced by Longman Group (FE) Ltd.
Printed in Hong Kong.

ISBN 0 582 03335 7

British Library Cataloguing in Publication Data
Palmer, Frederick
 The visual elements of art and design
 1. Visual arts – For schools
 I. Title
 700

 ISBN 0-582-03335-7

Acknowledgements

We are grateful to the museums, galleries and photographers acknowledged in the captions, for permission to reproduce photographs.

In addition I should like to thank Michael Kauffmann, Director of the Courtauld Institute and Giles Waterfield, Director of the Dulwich Picture Gallery for their kindness in allowing me to reproduce works from their collections. I am also grateful to my two sons, Jake and Luke, for their assistance with photography and picture research.

Contents

To Mother, Father and Dodie

'Seeing is of itself a creative operation, one that demands effort.'
Henri Matisse
1953

Introduction

To devise an art and design course which deals with the basic visual elements in isolation is to run the risk of setting up a narrow approach to the subject which will be a limitation rather than a liberation to the student. It will certainly be contrary to the spirit of contemporary art and design education and to the broad educational principles which the GCSE seeks to promote.

This book, therefore, has been produced as a resource for those planning broader project-based courses rather than to give support for a course based exclusively on the visual elements of art and design. Whatever theme is being explored, the student will have to study some aspects of the visual elements in relationship to it, just as consideration will have to be given to working procedures and appropriate contextual links.

One of the difficulties facing the author of a book such as this is how to overcome the assumption by readers that it presents a method of dealing with the subject which the writer considers to be the best or correct way. Let me state, therefore, at the beginning of this introduction that I do not believe that the subject of this book should be the sole consideration of the teacher and student of art and design education, but rather an integral part of whatever course is undertaken; integral, that is, not independent; essential, but not separate.

In the 1960s the main initiative in art and design education was known as Basic Design and stemmed from the teaching of Paul Klee, Wassily Kandinsky and others at the Bauhaus in Germany and the Black Mountain College in America. In the minds of some this was a passing fashion, to others a formalisation of what had been previously known and dealt with in an almost intuitive way. Some pedagogues thought it the salvation of art education – seeing it as the provider of an almost factual basis to the teaching of the subject – a structure which would help to make art and design an academically respected part of the curriculum. There were, however, those who were deeply concerned that the notions underlying the approach could lead to the establishment of a rigid system of learning and teaching, the production of a dogma which would be no less prescriptive, formalised and limiting than the approaches it sought to displace. In addition there was the danger that a concentration on the formal aspects of the subject would lead to the production of facile design and superficial abstraction. If, in retrospect, we can see that this did happen in some instances leading to the discrediting of Basic Design, we should also be able to appreciate and acknowledge the system's good points.

Whilst we may still view Basic Design with some suspicion, we can

also see what it has contributed to the formation of current educational thinking in the visual arts. Much of what we currently regard as good practice was present during the period of Basic Design but was over-shadowed at the time by formal abstract exercises. There was a desire on the part of many of the leading teachers concerned for work from direct observation, the drawing of natural and man-made forms, colour matching and at times a freer, more expressive approach. It is true, however, that the non-figurative exercises, the stylised solutions to so-called visual problems, and a concentration upon abstraction became almost a formula. It is possible that an undue concern for the 'vocabulary and grammar' of art and design, at the expense of the other aspects of the subject, led to a sterility of ideas and limited creativity. The requirements of the GCSE for active learning, resource-based learning and self-directed study preclude the narrow interpretation of Basic Design and place an understanding of the formal visual elements alongside an awareness of working methods and an appreciation of context as a necessary part of the students' experience, and not as an isolated concern.

In this book, the areas of study and the illustrations which accompany them do not present a complete account of the visual elements. Such a compilation would be unwieldy, as would details of all the possible links and permutations between areas. Consequently, some of the suggested areas of study appear in certain sections of the book, but not in all, for I have tried not to be too repetitive and have left the reader to transfer ideas across the sections. In most cases the pictures are examples of more than the one aspect of the element they represent, even though this has not been explained in the text.

An additional consideration when selecting illustrations has been the ease with which the areas of study could be represented by well-known works of art and design. Whilst no claim can be made for a unique or completely unfamiliar selection, an attempt has been made to avoid duplicating those items which the teacher will probably already have in other books, slides and postcards. Where possible, works in British museums have been used and those from private collections are suggestions for consideration rather than specific items for study.

Many of the images serve not only to illustrate aspects of the elements, but also to show how people have used them to communicate their ideas, observations and feelings. In addition they can be seen as indicators of possible directions for investigation, analysis and interpretation and as additional themes for project-based learning.

Personal interest, as well as the cost and availability of reproductions, is a major factor in the compilation of images for any book however much the author aims to be objective. My selection here is personal, perhaps at times idiosyncratic, for whilst attempting to clearly illustrate the main areas for consideration, I have also sought to present links and juxtapositions which make additional points. I have been concerned to show something of the achievements of women artists and designers; to indicate cross-curricular and cross-cultural relationships; and to show that there is more to the subject than a conventional reliance on the fine art tradition of Western Europe. I have also wished to gently remind the reader that students need guidance in order to make serious critical appraisal of the non-figurative, the experimental, and the unusal (even though this has proved difficult with past examination systems) and to realise that enjoyment and humour do not devalue either art or education.

Whilst it might be thought by some that much of what is required by the examination groups of the GCSE is traditional, it should be remembered that most of what is expected is new to the students. If, as teachers, we can build on their curiosity without undue repetition and with our own creativity and excitement evident; attempt to devise projects which stimulate a desire for study and experiment, re-interpreting what to us might be familiar; then there is a good chance that those ideas and ideals in which we believe may be understood and extended by those we teach.

Line

Without underestimating the problems of devising a system for working creatively in the visual arts, Wassily Kandinsky attempted in his books, *Concerning the Spiritual in Art* (1912) and *Point and Line to Plane* (1926), to link the spectator's response to the type of line, shape and colour used by the artist. Although too great an emphasis on such relationships will restrict the artist and probably fail to elicit the required response from the spectator, there are qualities in the visual elements to which we react intellectually and emotionally. In this section there are suggestions that:

■ vertical lines – can indicate strength, perhaps growth;
■ horizontals – calm and rest;
■ curves – smoothness;
■ diagonals – movement; and
■ zigzags and other articulated lines – a feeling of agitation.

Line is a means of communication rather than a natural phenomenon, a device we use to describe what we see, a means by which we convey our reactions to both reality and concept, and an element with which we express our thoughts and feelings.

Line can indicate movement

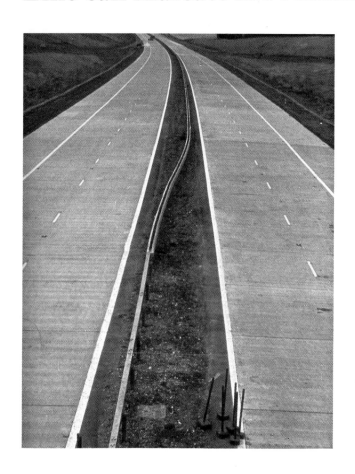

Motorway

Figure on Horseback. Mervyn Peake. *c.*1950. Pen and ink. 25 × 34 cm. Private collection.

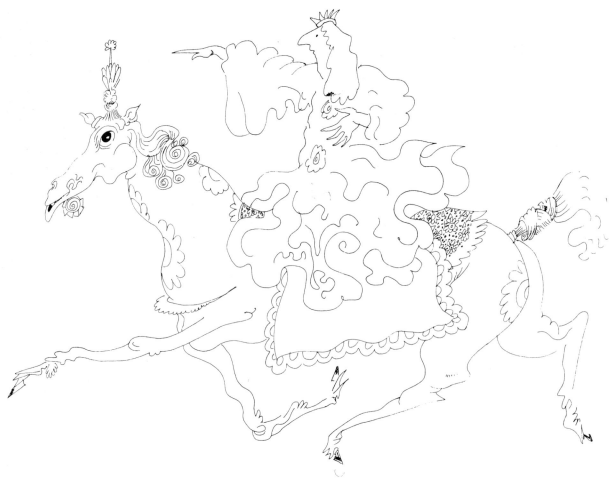

Line can be the place where two areas meet

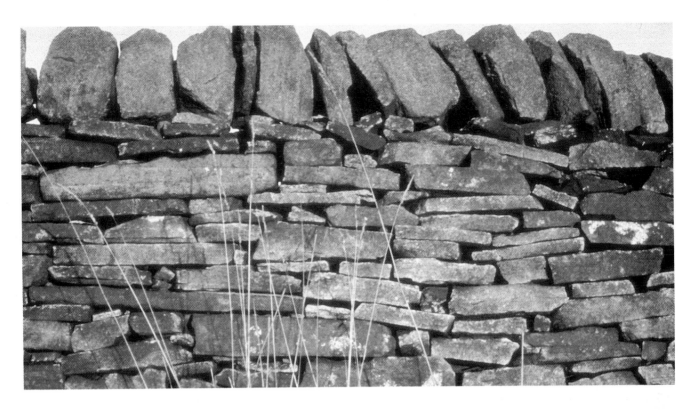

Dry stone wall. Derbyshire.

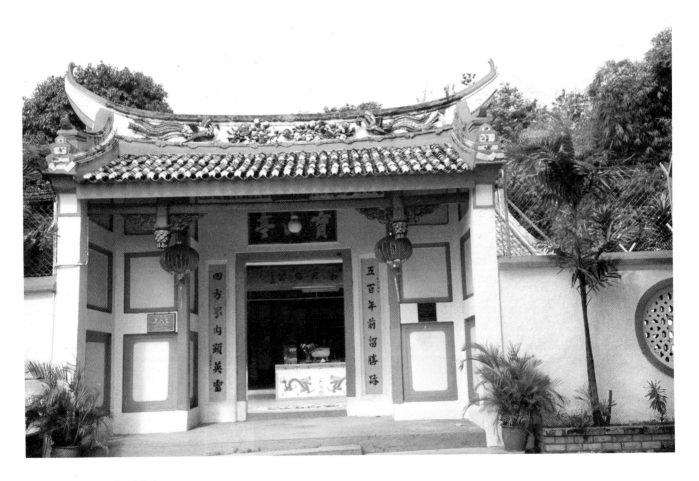

Chinese temple. Malacca.

Line can be contour

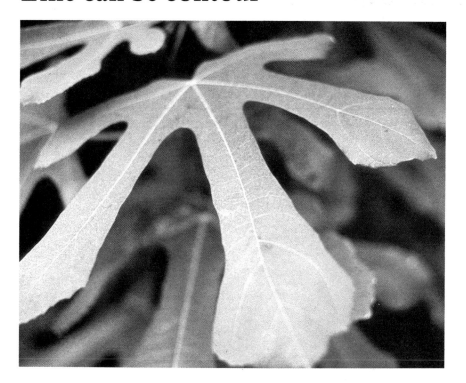

Fig leaf.

Late Iron Age torc from Snettisham made of an alloy of gold and silver. The British Museum, London.

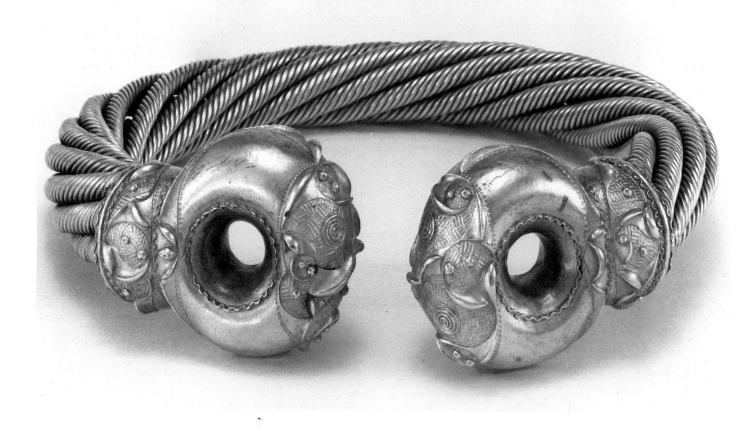

Line can be extended shape

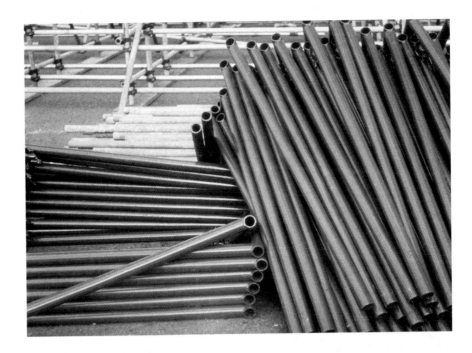

Stacked scaffolding.

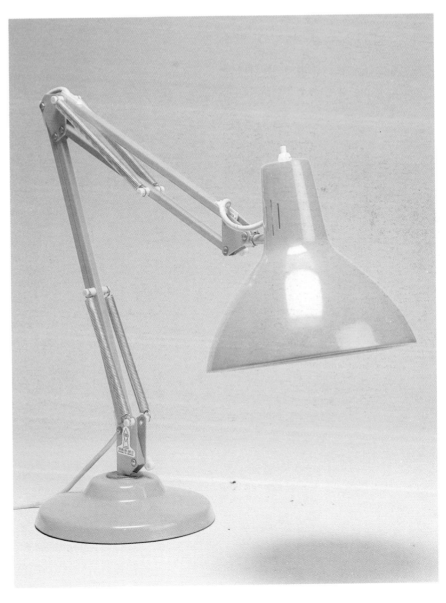

Anglepoise lamp.

Verticals

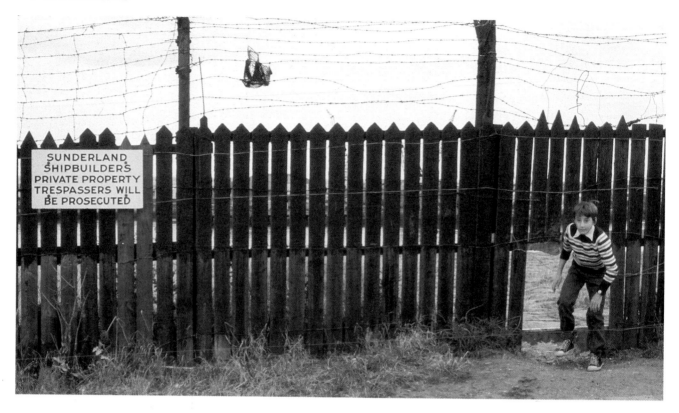

Wooden fence.

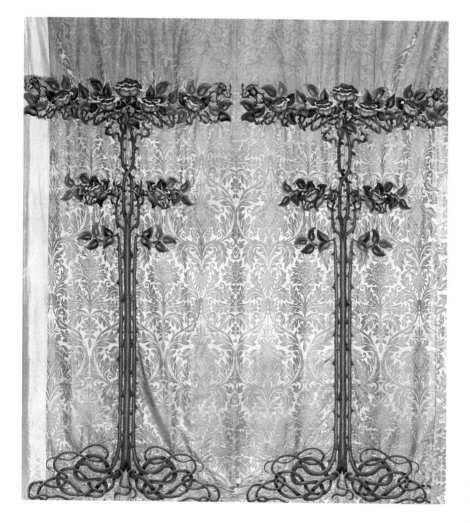

Embroidered curtains from
Fanham's Hall, executed by
Royal School of Needlework.
c.1905. The Victoria and Albert
Museum, London.

Horizontals

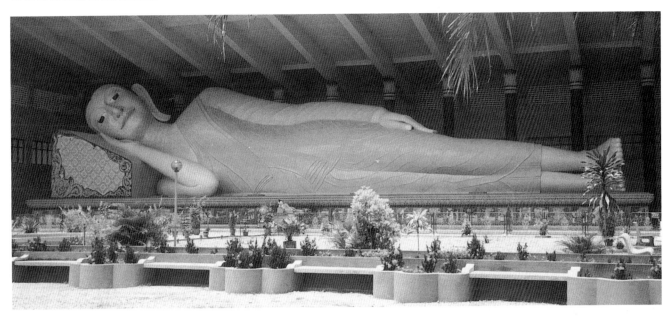

Reclining Buddha. Malaysia.

Man Lying on a Wall. L.S. Lowry. 1957. Oil on canvas. 40.7 × 50.9 cm. City of Salford Art Gallery.

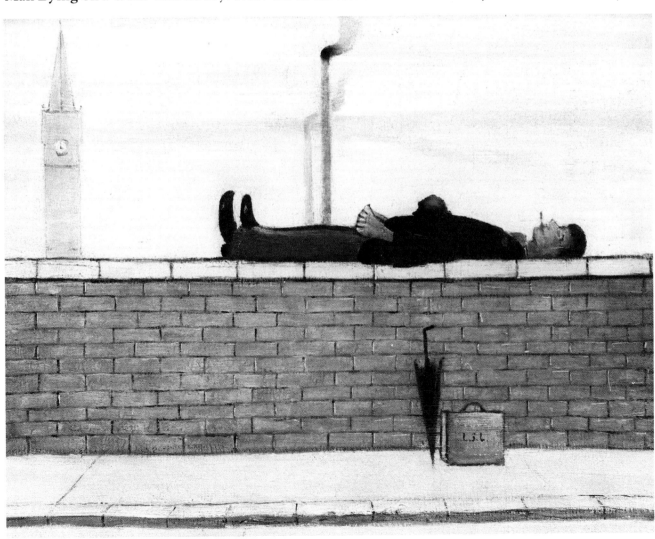

Diagonals

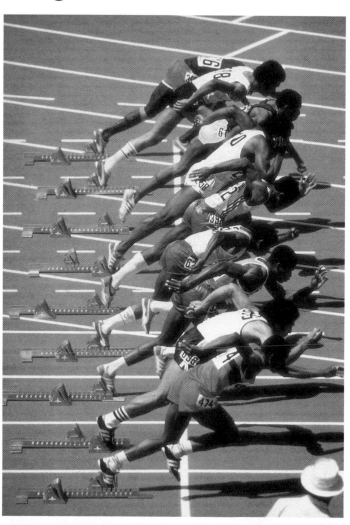

Sprinters starting.

Samson and Delilah. Anthony Van Dyck. *c.* 1618. Oil on canvas. 151.4 × 230.5 cm. The Dulwich Picture Gallery.

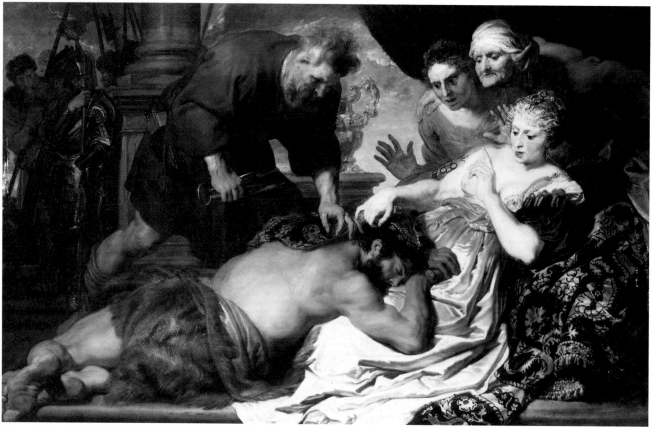

Curves

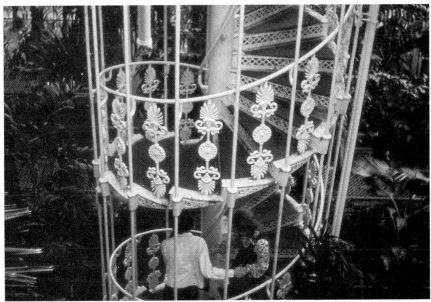

Spiral staircase.

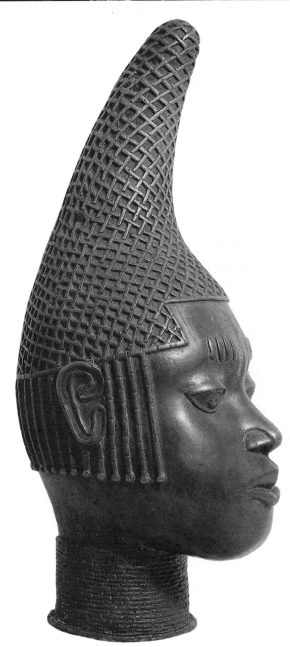

Queen Mother Brass Head.
Benin, West Africa. Fifteenth
century. Museum fur
Volkerkunde, Berlin.

Zigzags

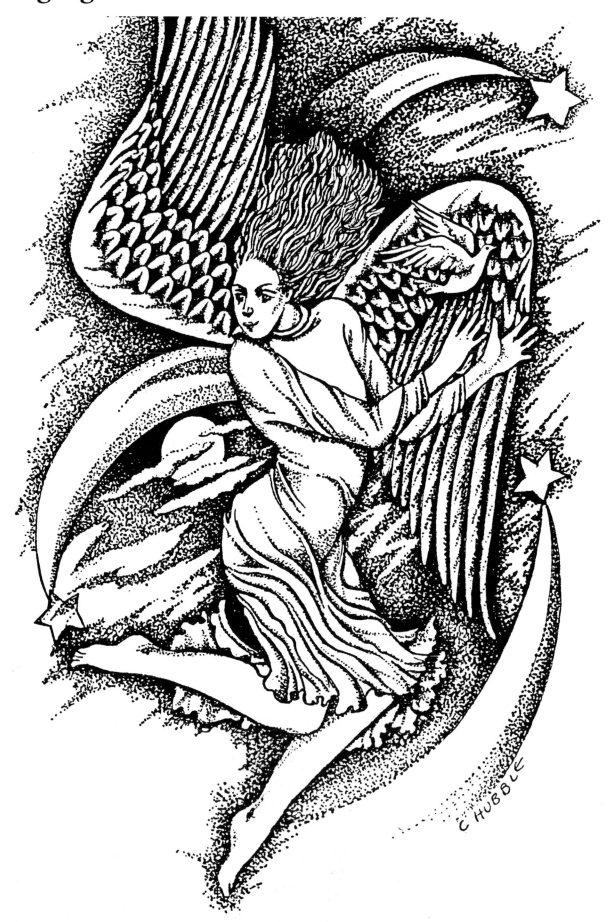

Christmas card. Carol Hubble. 1987. Courtesy of the artist.

Line can create shape

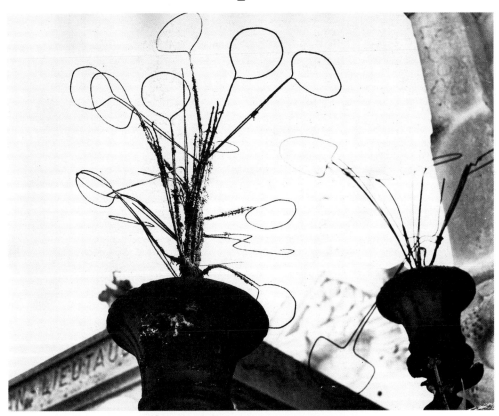

Wire flower stems and urns.

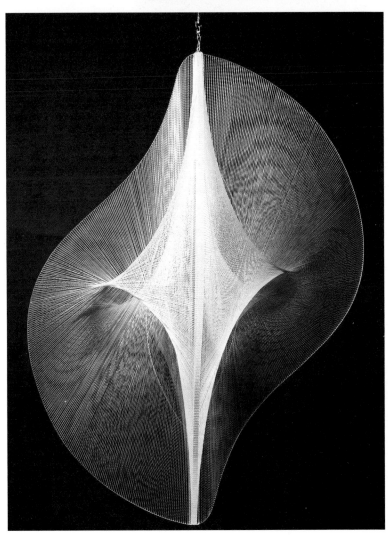

Linear Construction No. 2.
Naum Gabo. 1970–71. Plastic with
plastic threads. 114.9 × 83.5 × 83.5 cm.
The Tate Gallery, London.

Line can create pattern

Shadows.

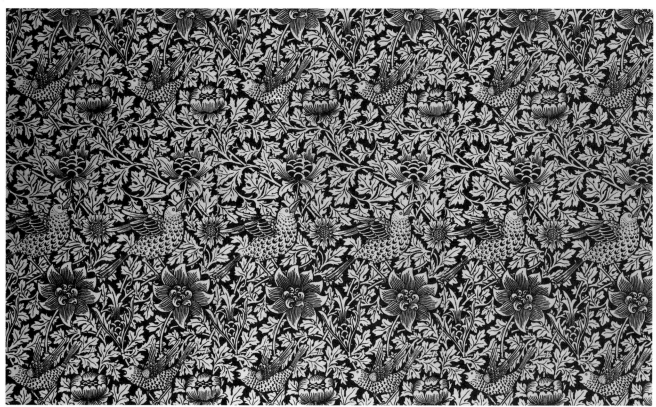

Honeysuckle. Mary Morris. 1883. Wallpaper printed by Jeffrey & Co. The Victoria and Albert Museum, London.

Line can create texture

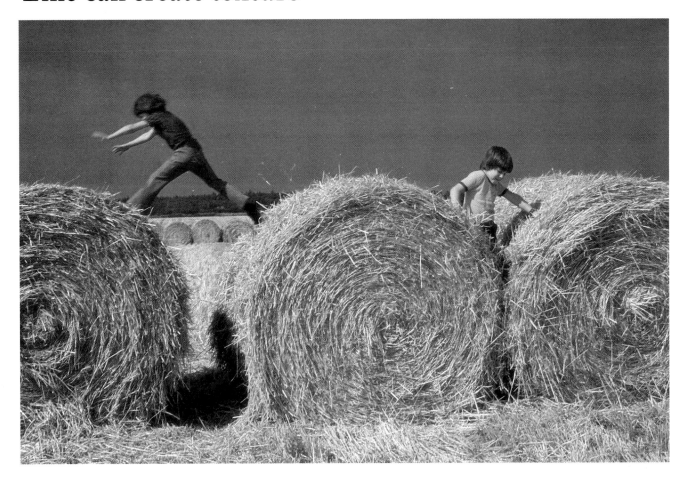

Straw bales.

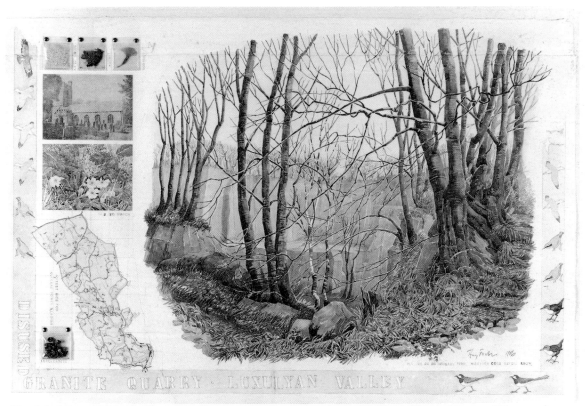

Parish Map 1986, A Granite Quarry in the Luxulyan Valley. Tony Foster. Watercolour and found objects. 106.6 × 76.2 cm. Courtesy of Common Ground.

Line can create rhythm

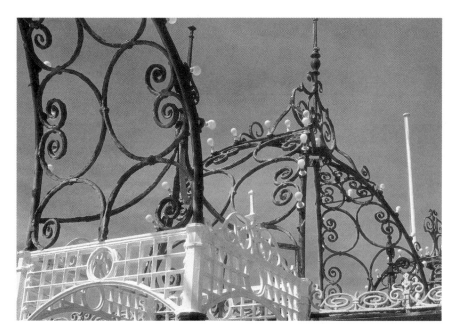

Wrought iron.

Design for a wallpaper. C.F.A.
Voysey. 1895. The Whitworth
Art Gallery Manchester.

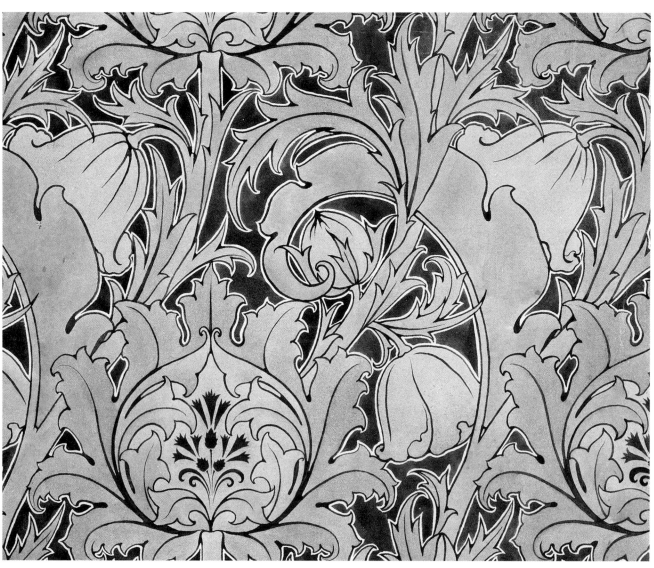

Line can create space

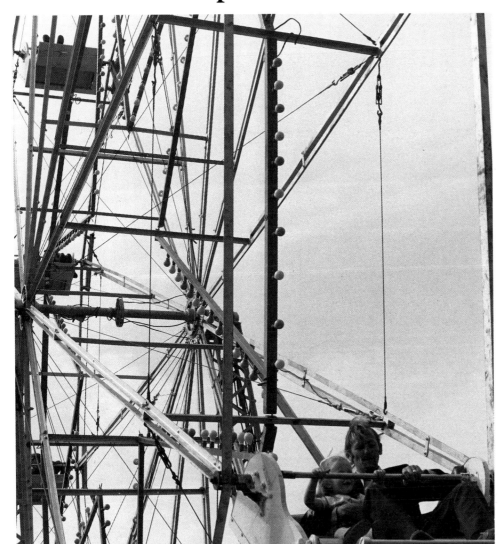

Fairground Big Wheel.

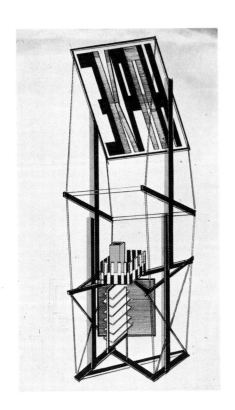

Project for Newspaper Kiosk. G. Klutsis. 1922. Arts Council.

Line can create form

Armpiece. Caroline Broadhead. 1962. Nylon monofilament. Crafts Council.

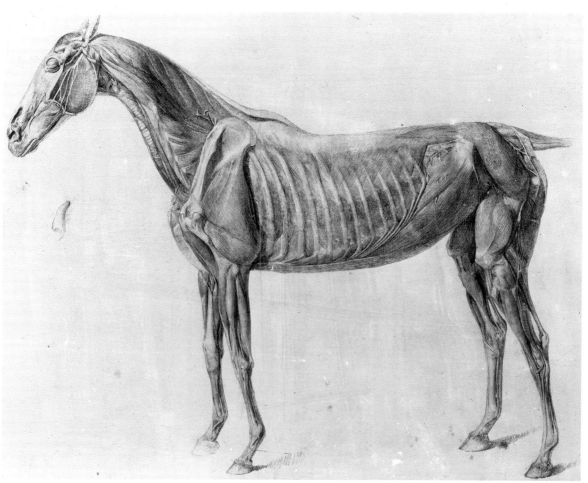

Drawing for **Anatomy of a Horse**. George Stubbs (1724–1806). Pencil on paper. 29.2 × 47 cm. Royal Academy of Arts.

Line can create communication

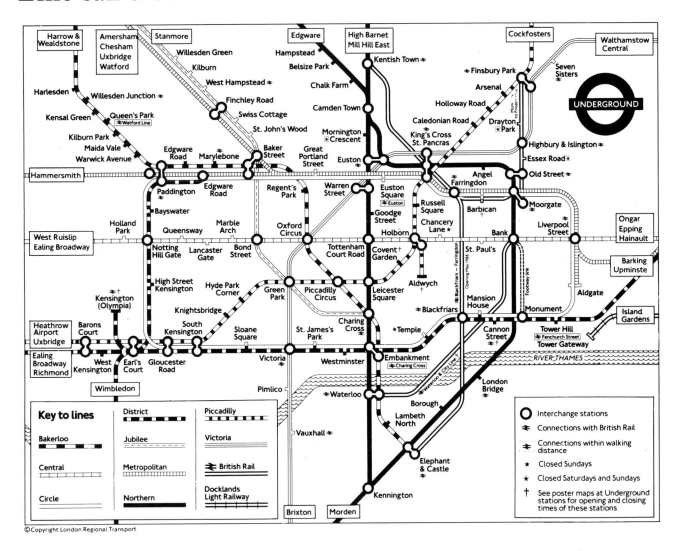

Map of the London Underground. London Regional Transport.

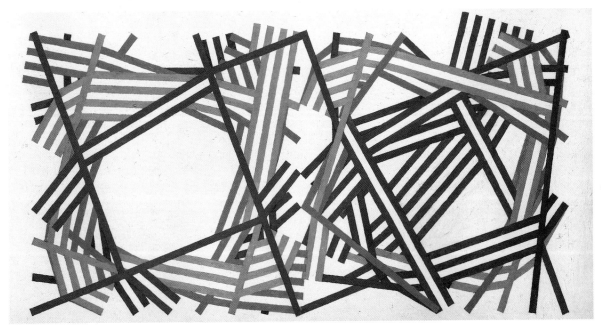

Chance, Order, Change 22 (4 Colours) Sheaves. Kenneth Martin. 1982. Oil on canvas. 51 × 91.4 cm. Collection of Adrian Heath.

Shape

In a manner similar to that of line, shape may be used by artists and designers to manipulate the spectator's response to an image or construction. For example:

- squares and rectangles are associated with stability;
- circles and curved shapes suggest movement and continuity;
- triangles can lead the eye in an upward movement; but
- inverted triangles tend to give a sensation of imbalance and tension.

Students need to understand these attributes of shape. They need to appreciate how a sense of stability is conveyed by pictures based on square and rectangular compositions, for example in some portraits, as well as in some paintings of the environment by such artists as Vermeer and de Hooch (see page 25); how the uplifting quality of many images of the Nativity and Crucifixion is aided by a triangular composition (see page 27); and how a sense of movement is aroused by the flowing shapes seen in paintings such as Bruegel's 'Wedding Feast' and Matisse's 'Dance'.

These attributes apply to sculpture, craft, graphic design, furniture and architecture, photography, film and television. Study of all the visual elements should extend into these areas of design, craft and media so that links with our everyday experience can be made and the student's creative and critical faculties extended.

Squares

Knapped flint and stone wall.

An Interior with a Woman Drinking with Two Men and a Maidservant. Pieter de Hooch (1629–after 1684?). Oil on canvas. 73.7 × 64.6 cm. The National Gallery, London.

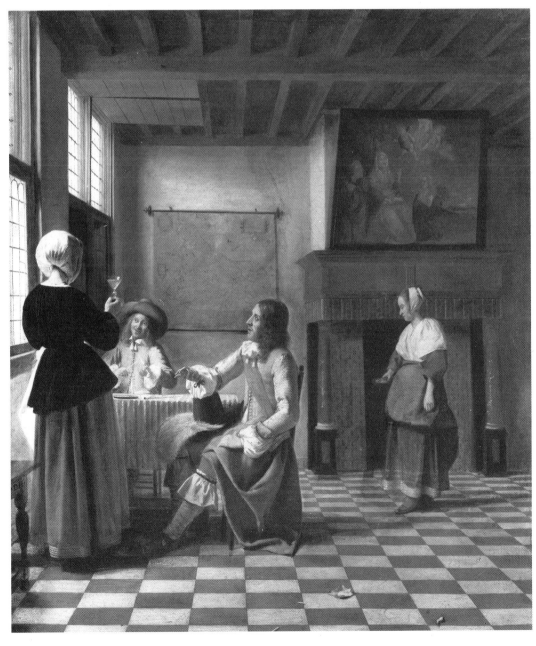

Rectangles

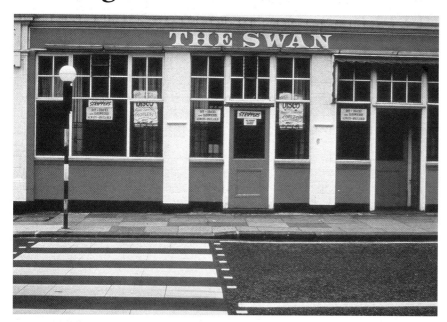

The Swan Pub.

African textile. (Ewe) Ghana. 1934. Cotton cloth. 279 × 188 cm. The British Museum, London.

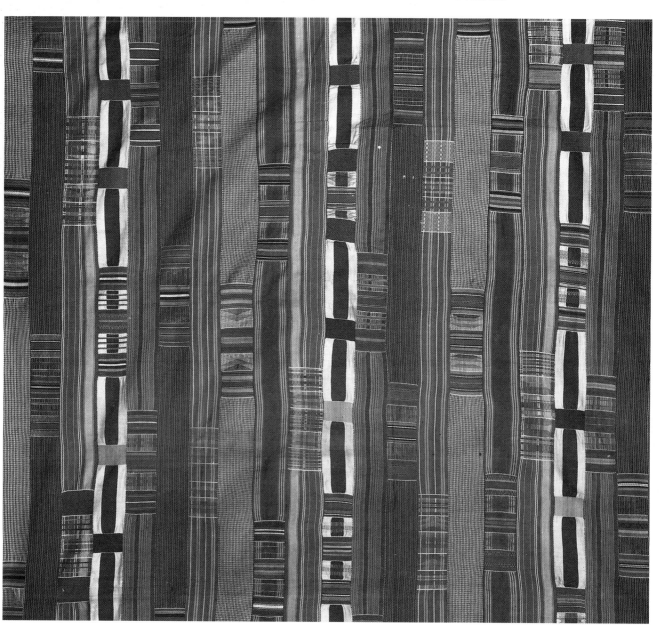

Triangles

Building at La Grande Motte, France.

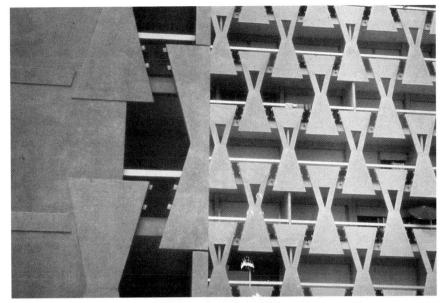

Virgin and Child with saints. Triptych (central panel). *c.*1515. Tempera on wood. 108 × 160 cm. The Master of the St Ursula Legend. Leeds Castle, Kent.

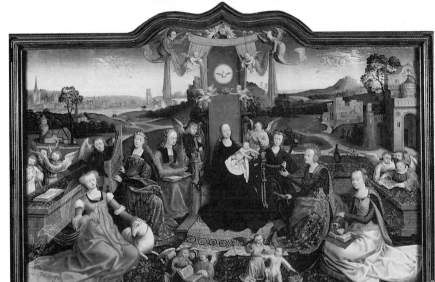

The Dinner Party. Judy Chicago. 1979. 14.6 cm each side. Triangular table with China-painted porcelain plates on hand-stitched runner; porcelain tile floor.

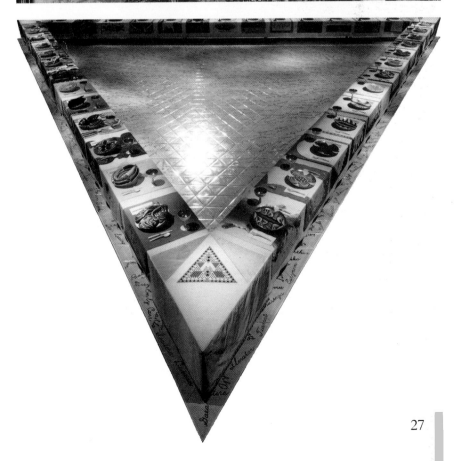

Curves

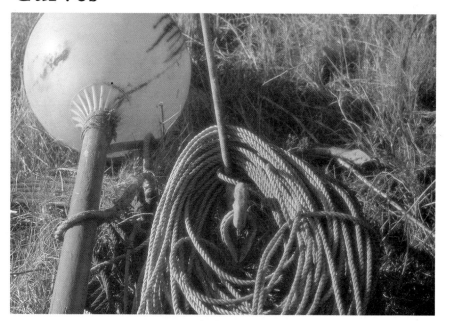

Bouy and rope.

Woman powdering herself.
Georges Pierre Seurat. 1889–90.
Oil on canvas. 94.2 × 79.5 cm.
Courtauld Institute of Art,
London.

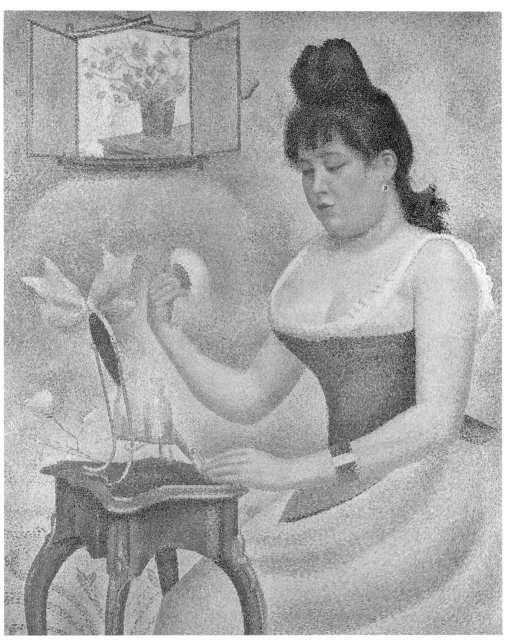

Circles

Waterwheels.

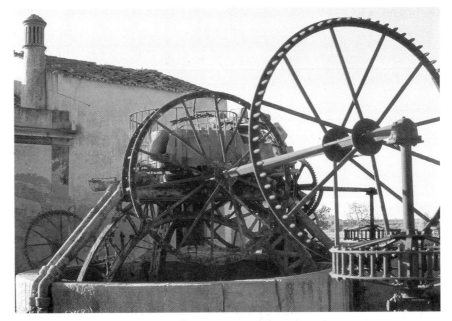

St George. Greek Icon. First half of the fourteenth century. 104 × 69 cm. Church of Zoodochos Pigi (Panagia Trypiti).

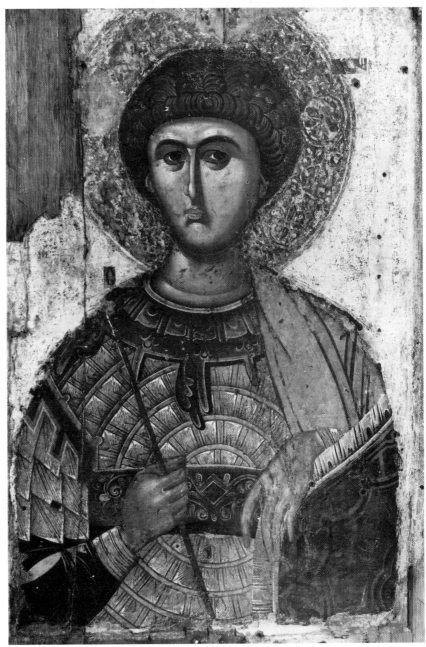

Functional shapes: natural

Coconut palm.

Bones.

Functional shapes: man-made

Toy clockwork tractor.

Coming into L.A. Keith Baugh. *c.*1985. Acrylic. 68.6 × 43.2 cm. Courtesy of the artist.

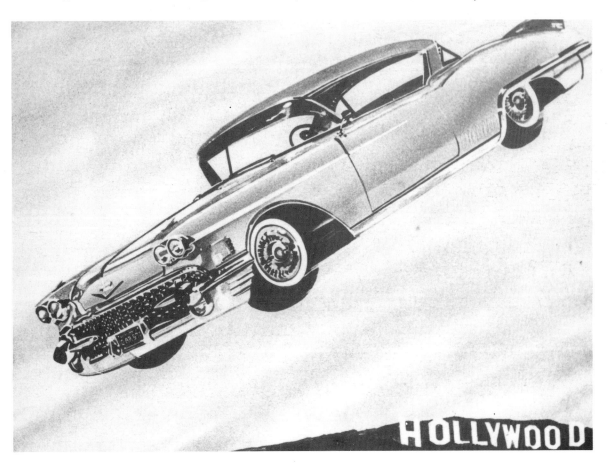

Structural shapes: natural

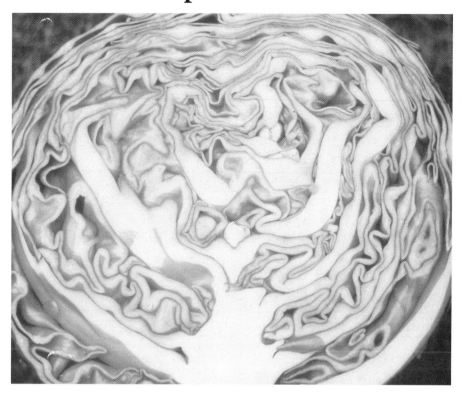

Red cabbage section.

Mountains at L'Estaque. Paul Cézanne. 1878–80. Oil on canvas. National Museum of Wales.

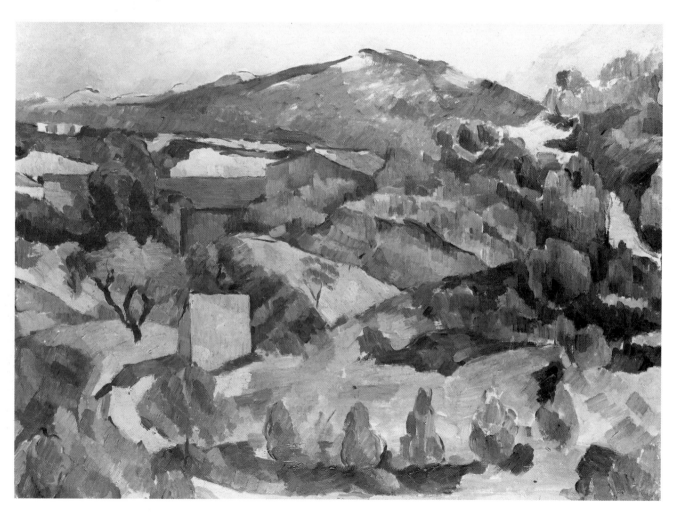

Structural shapes: man-made

Bell bouy.

Interior of the Stables, Royal Pavilion, Brighton. William Porden. 1803–08. Watercolour. 25 × 31.8 cm. Royal Pavilion, Brighton.

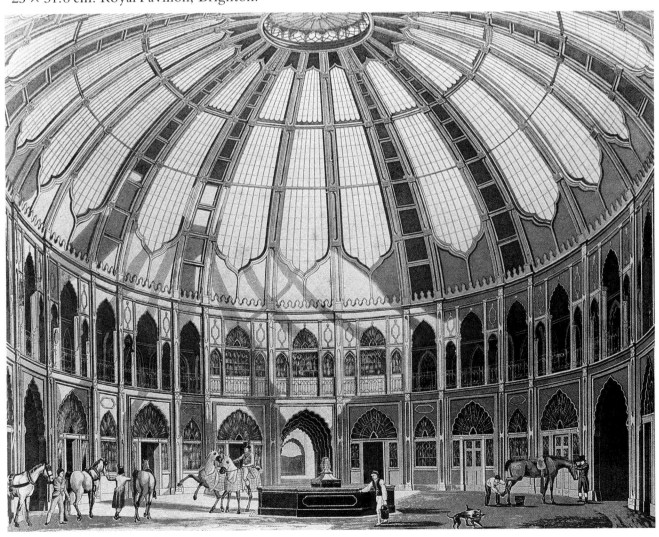

Natural packaging

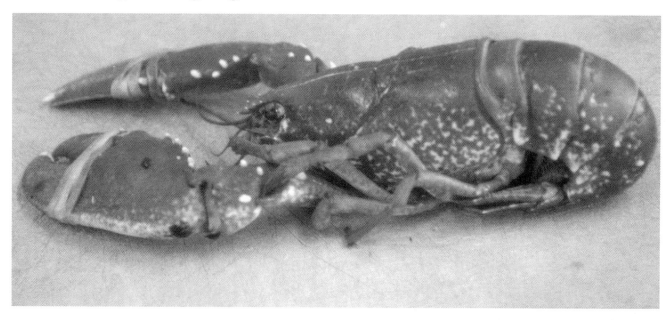

Lobster. Photograph by David Pratt

Two bamboo-form spill vases. Chinese. *c.*1740–50. Porcelain with pale celadon glaze and French ormolu mounts of the period. 17.8 cm high. The Victoria and Albert Museum, London. Although not natural forms, these vases echo the bamboo they have been designed to hold.

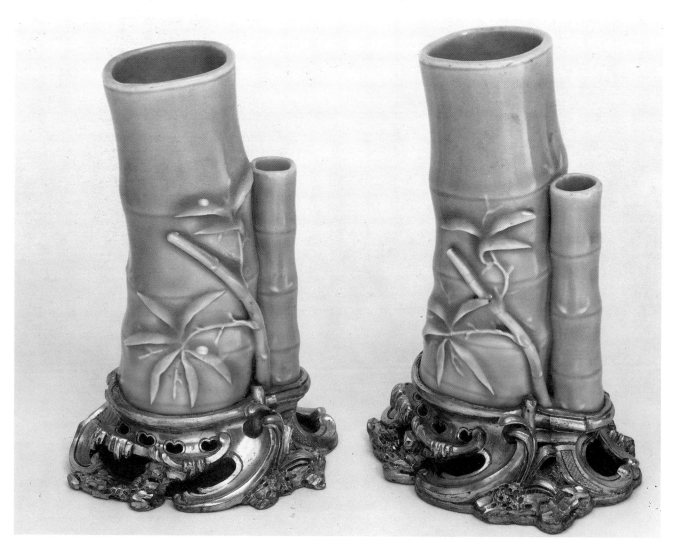

Man-made packaging

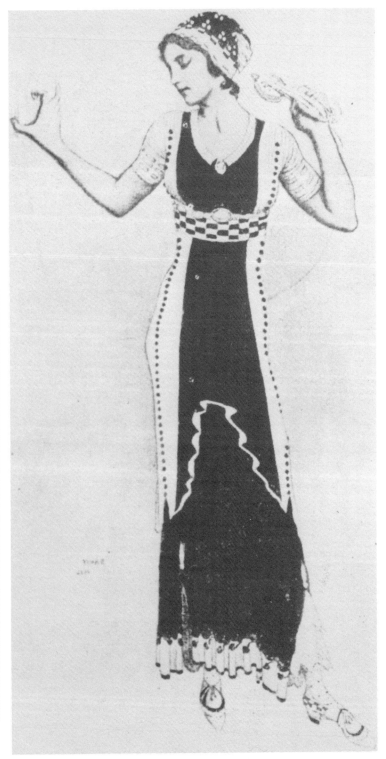

Above: Armour of Archduke
Ferdinand of Tyrol (1529–95).
The work of Jakob Topf, court
armourer of Innsbruck. 1582

Above right: Fashion design.
Leon Baxst. 1912. Whereabouts
unknown.

Shape as decoration

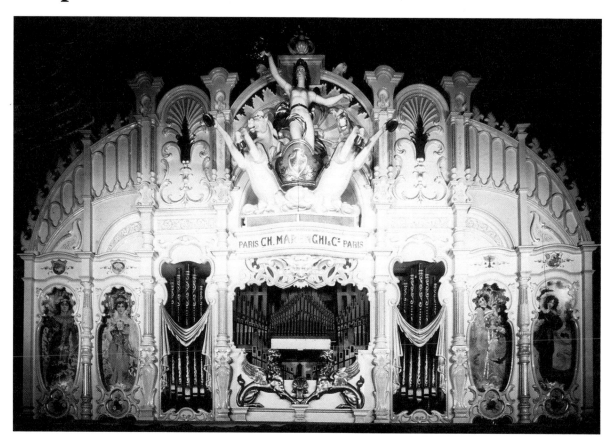

98 Key Showman's Organ. Charles Marenghi. 1905. Steam and Organ Museum, Thursford, Norfolk.

Christian Coptic Church Painting. Byzantine. *c.*Eighteenth-century Ethiopia. The Horniman Museum, London.

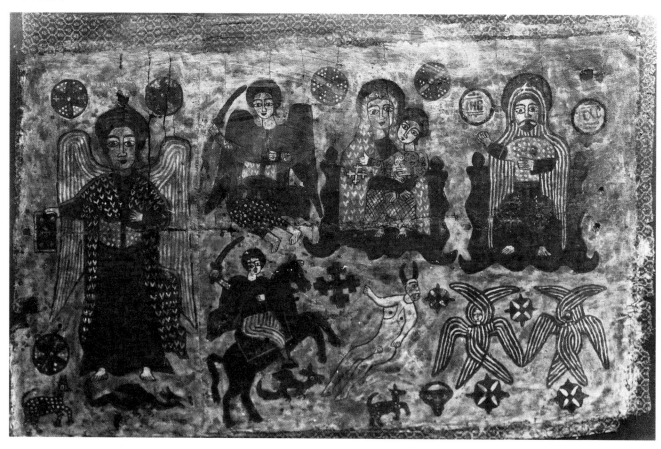

Shape as communication

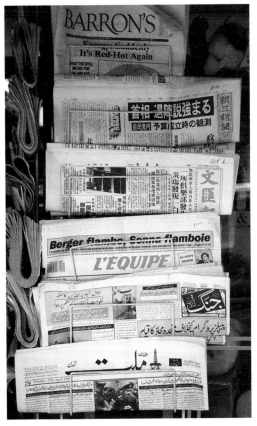

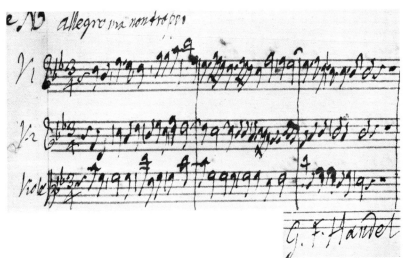

Part of a concerto by Handel (1685–1759).

Newspapers.

Treatise. Music score. Cornelius Cardew. 1963–7. Arts Council.

Shape as symbol

Trademark.

Pictograph.

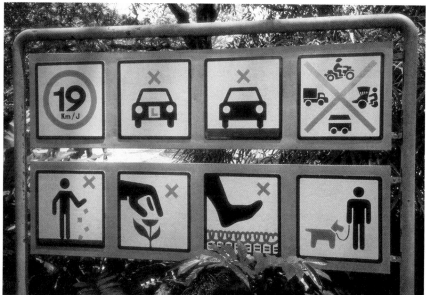

Roadsign.

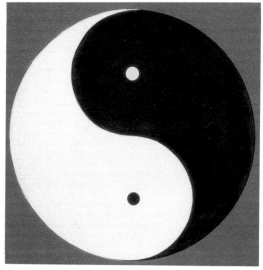

Yin and yang.

Positive and negative shapes

Figure silhouettes.

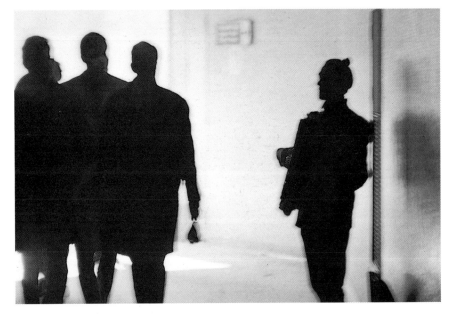

Sir Thomas Bullen K.G. 1538. Brass rubbing. Hever Church, Kent. The Victoria and Albert Museum, London.

Men on scaffolding.

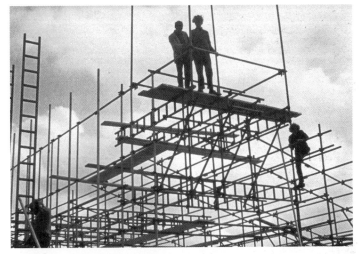

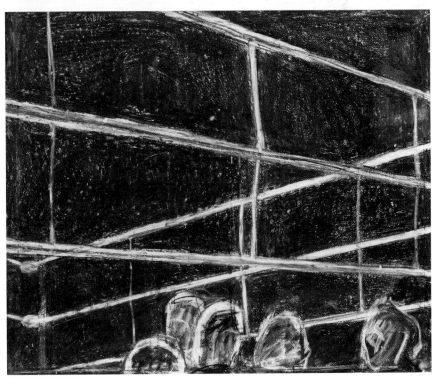

Ringside I. Sam Rabin. Wax crayon on board. 51.6 × 62.1 cm. Private collection.

Counterchange

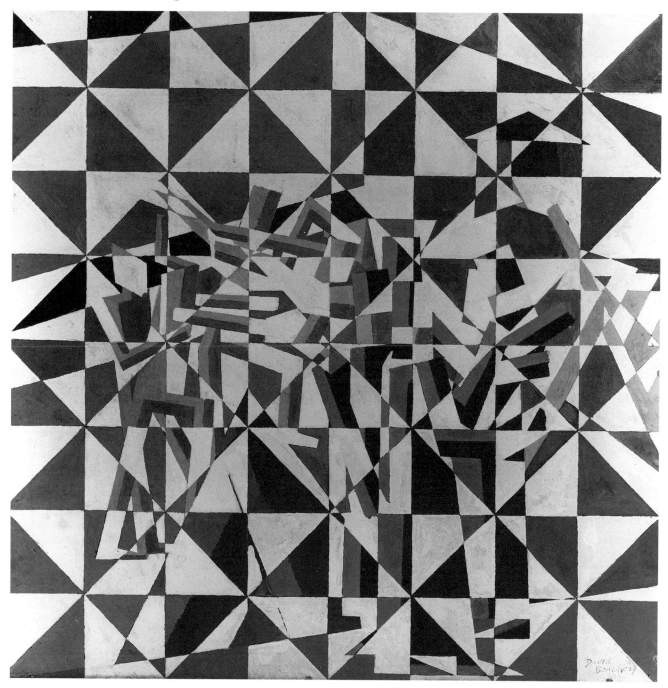

Ju-jitsu. David Bomberg. *c.*1913. Oil on board. 62 × 62 cm. The Tate Gallery, London.

Tone

The variations of lightness and darkness between the extremes of neutral black and white are illustrated here largely with examples from the work of artists and designers rather than the environment in an uninterpreted form.

It is worth remembering, when dealing with this visual element, that the student can be encouraged to use tone in a creative way, to evoke responses from the spectator and not simply to show how correctly nature may be copied. For example, tone may be used to:

- create pictorial structure with balanced light and dark;
- convey harmony, or alternatively disunity;
- indicate dramatic contrast;
- give the illusion of solidity;
- suggest qualities of light;
- evoke a sense of space and distance;
- compose rhythms across a picture or construction; and
- pattern areas with positive and negative shapes.

Monochrome

Moscow 1983. Photograph by Barry Lewis. Network.

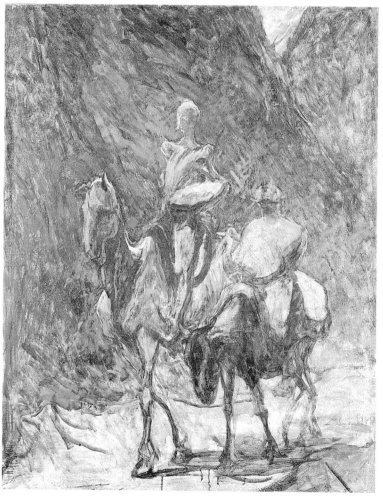

Don Quixote and Sancho Panza. Honoré Daumier. *c*.1865–73. Oil on canvas. 100 × 81 cm. Courtauld Institute of Art, London.

Grisaille

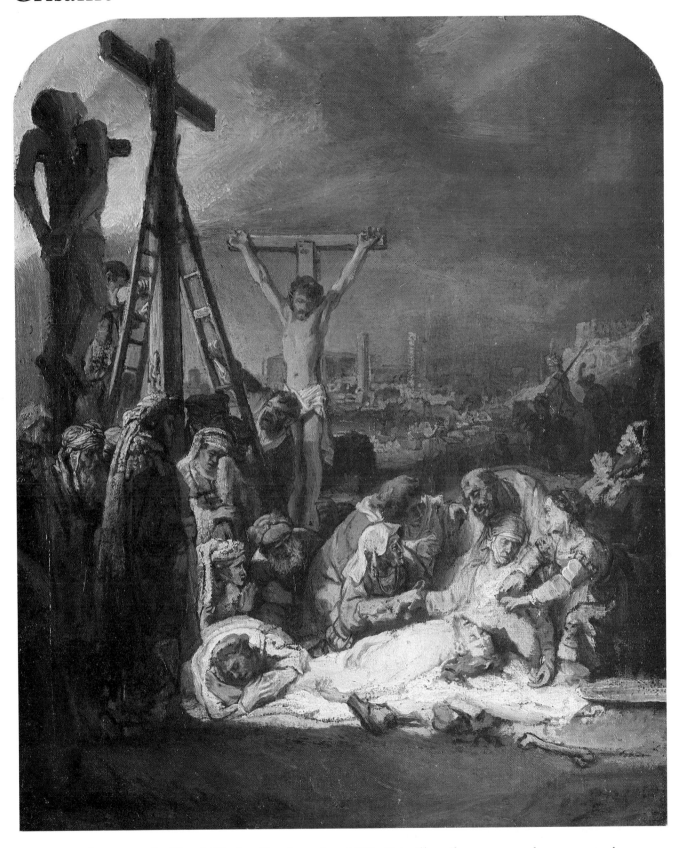

Lamentation over the Dead Christ. Rembrandt. *c.*1638. Grisaille, oil on paper and canvas, stuck on wood 31.9 × 26.7 cm. The National Gallery, London.

Tone in drawing

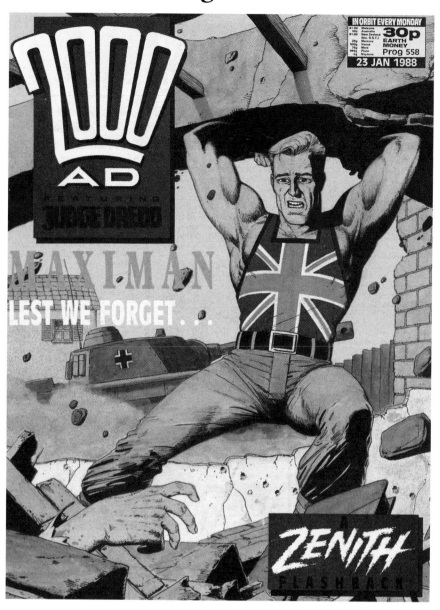

2000 AD comic cover. Fleetway Publications.

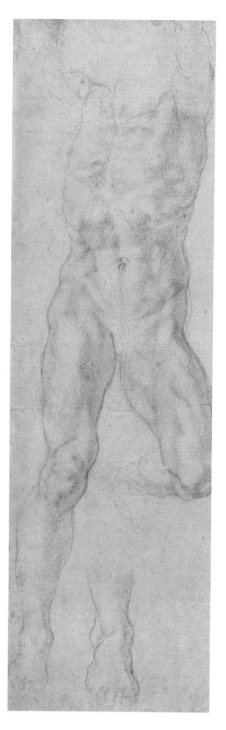

Figure drawing. Michaelangelo
Buonarroti (1475–1564).
39 × 19.5 cm. The British
Museum, London.

Tone in painting

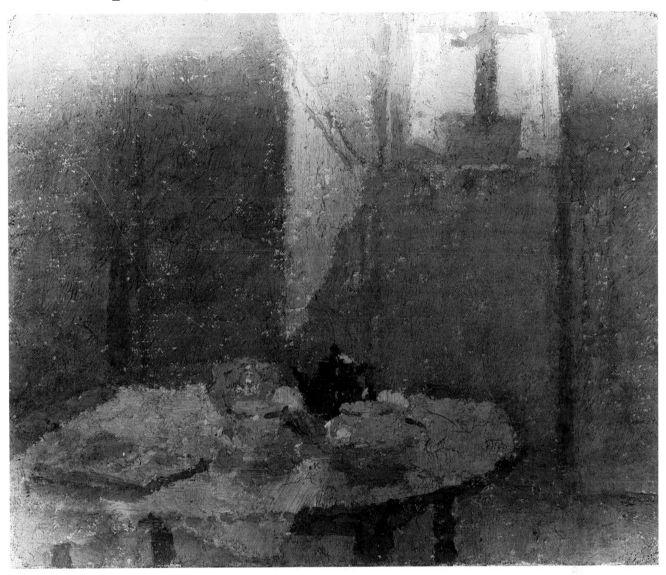

Interior (Rue Terre Neuve). Gwen John. 1924. Oil on canvas. 22 × 27 cm. Manchester City Art Gallery.

Tone in printmaking

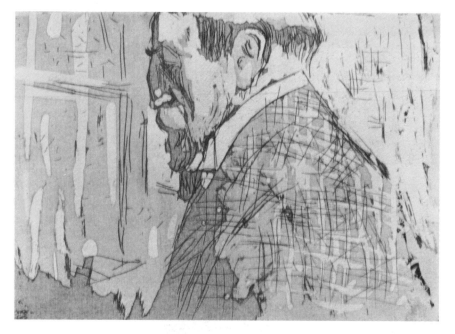

Portrait. Edouard Vuillard. *c*.1895. Etching and aquatint. 10 × 13.5 cm. Private Collection.

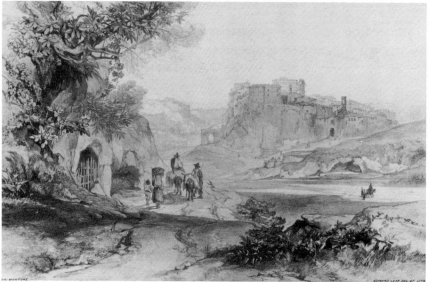

Landscape: Valmontone (from his *Views of Rome and its Environs*). Edward Lear. 1841. Lithograph. 24 × 34 cm. Private collection.

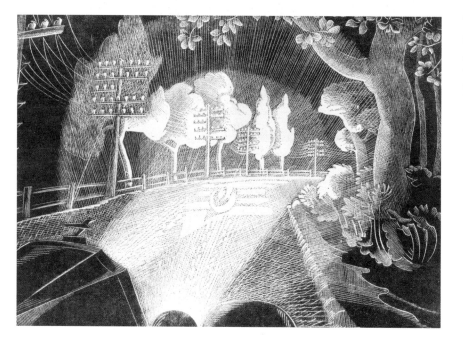

Through the Windscreen. Gertrude Hermes. 1926. Wood engraving. 12.7 × 17.8 cm. Towner Art Gallery, Eastbourne.

Tone in photography

Salvation Army poster.

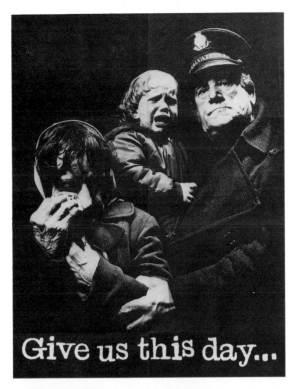

French cemetery.

High key

Boys in a Spanish village.

Top of the Mountain. Anthony Eyton. 1987. Oil on canvas. Browse and Derby, London.

Middle tone

Underground to Escape the Fog. Designed by A.E. Halliwell. London Transport Museum.

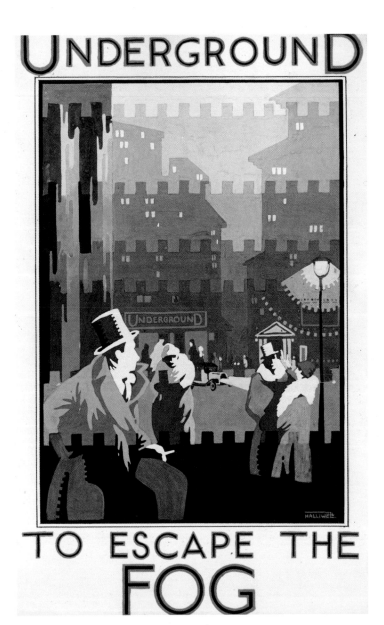

Nocturne in Blue and Green. James McNeill Whistler. 1871. Oil on panel. 50.2 × 59.1 cm. The Tate Gallery, London.

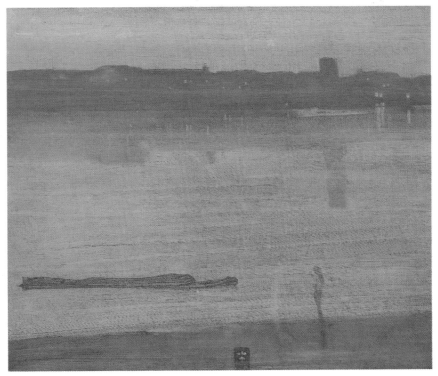

Low key

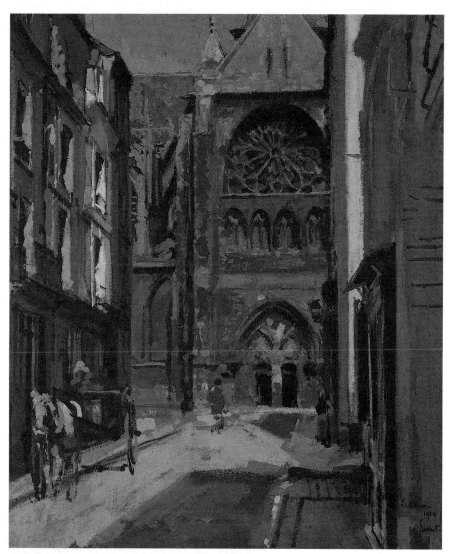

Le Rue Pecquet, Dieppe.
Walter Richard Sickert. 1900.
Oil on canvas. 54.6 × 45.7 cm.
City Museum and Art Gallery,
Birmingham.

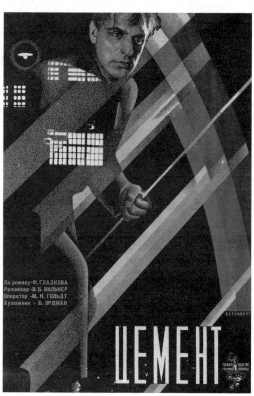

Cement. The Stenberg
Brothers. 1927. USSR Film
Poster. 107 × 71 cm. Riverside
Studios.

Chiaroscuro

Chapelle St Sixte. Provence.

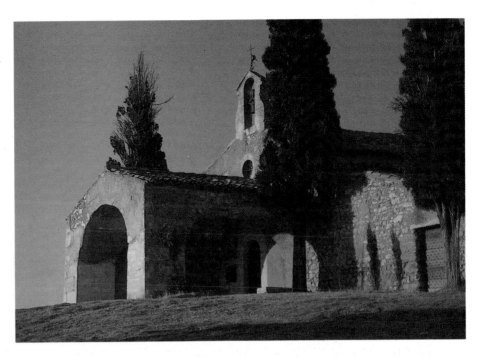

The Concert. Hendrick ter Brugghen (1588–1629). Oil on canvas. 99.1 × 116.8 cm. The National Gallery, London.

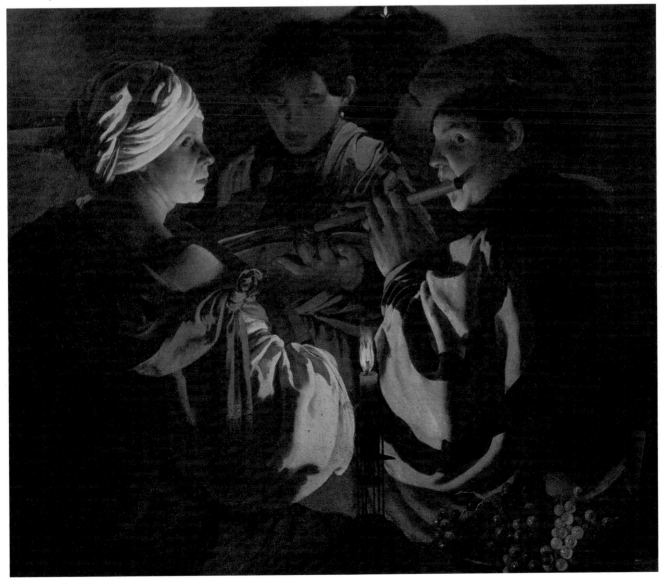

Tone and space

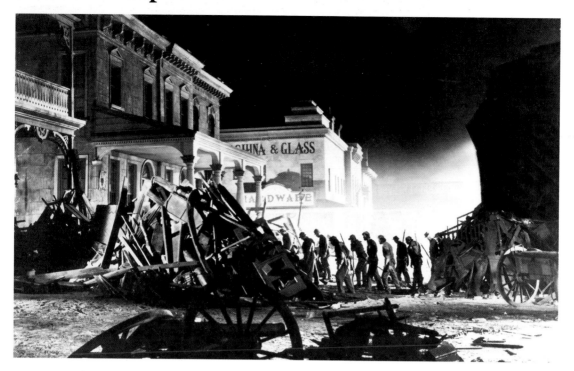

Film still from *Gone With the Wind*. MGM/UA.

Seaport: The Embarkation of the Queen of Sheba. Claude Lorraine. 1648. Oil on canvas. 1.485 × 1.94 m. The National Gallery, London.

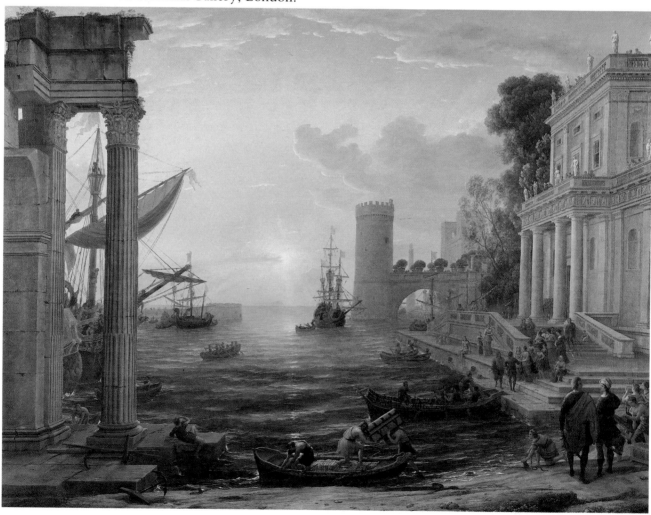

Tone and mood

River scene.

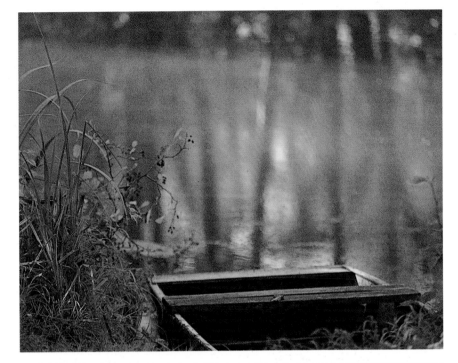

Harvest Moon, Shoreham.
Samuel Palmer. *c.*1830–31.
Watercolour and body colour on
panel. 12.5 × 14 cm. Carlisle
Museum and Art Gallery.

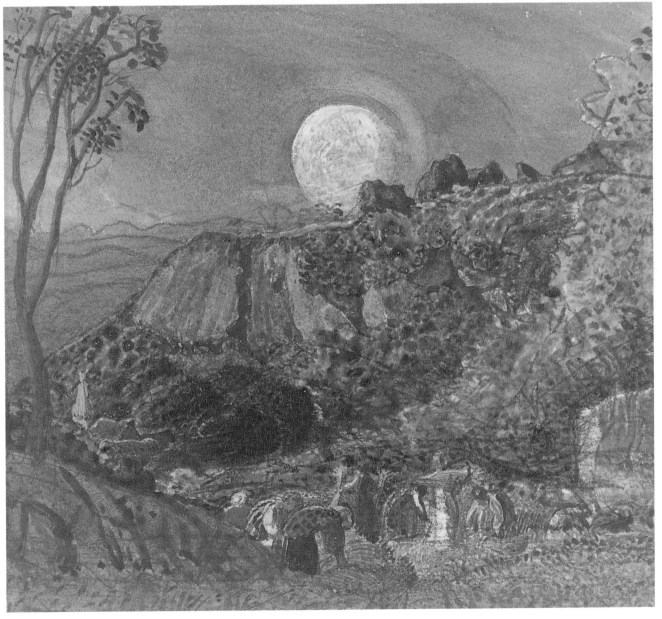

Colour

Colour is probably the visual element to which initially we respond most strongly. It arouses feelings in us all and we use it to reflect our personality and moods in the decoration of ourselves and our environment. The relationships to symbolism, psychology, physiology, physics and other social and scientific areas are complex and this is not the place for any detailed account or analysis.

As with the introductory comments to the other elements, the suggested areas of study listed here are basic and must act as 'trigger-mechanisms' for research, rather than a definitive breakdown of the subject. The experienced teacher will know what aspects of colour are applicable for study at different stages of the student's course and will be aware of other books and resource materials which deal with the complexities of colour. What is given here is a basic list with illustrations which point to further areas of study.

Primary colours

P&O poster.

Circus poster.

The Three Hierarchs. Vistea, Fagaras, Rumania. First half of nineteenth century. Icon painted on the back of glass. The Horniman Museum, London.

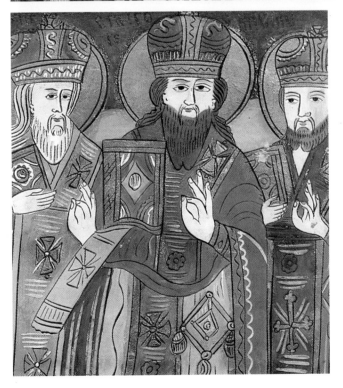

Secondary colours

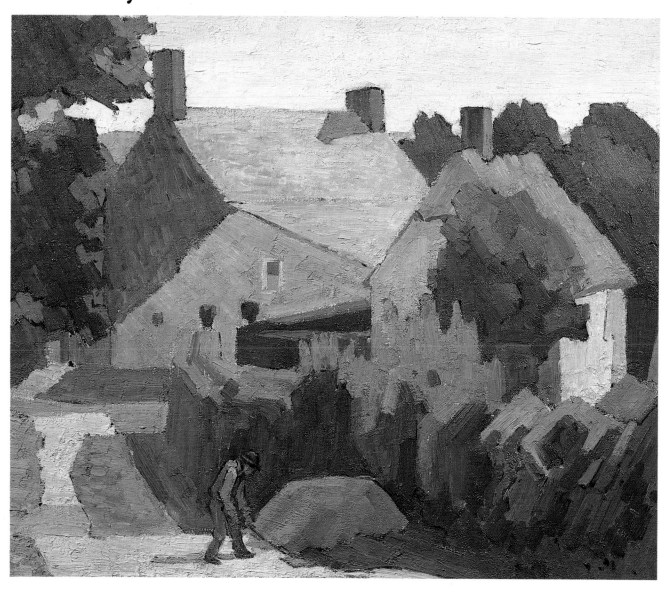

Dunn's Cottage. Robert Bevan. 1915. Oil on canvas. 48 × 56 cm. Leeds City Art Gallery.

Secondary colours are made with mixtures of two primaries and are: green made with yellow and blue, violet made with red and blue and orange made with red and yellow.

Tertiary colours

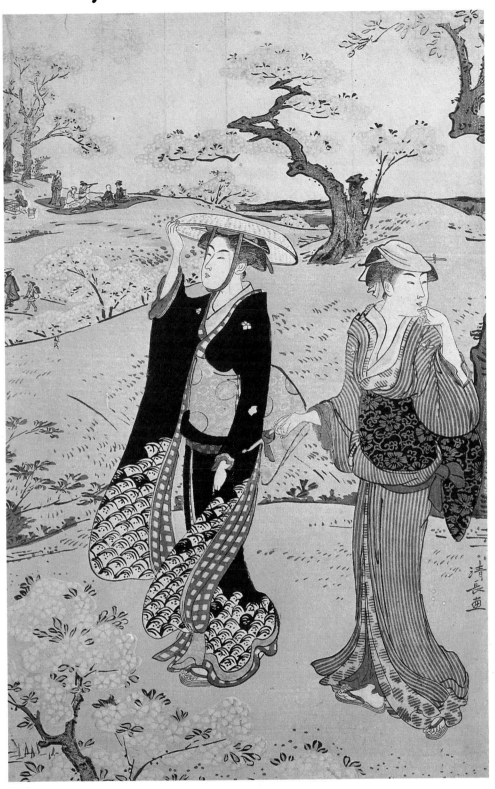

Cherry Blossoms at Asakayara near Edo. Torii Kiyonaga. c. 1777–78. Japanese woodcut. Centre portion of triptych print. 36.2 × 24.1 cm. Victoria and Albert Museum, London.

Tertiary colours are those which are made by adding larger amounts of one primary colour to another. For example, as shown here, the orange-red which is between red and orange and the green-yellow which is between yellow and green.

Obviously, the illustrations for primary, secondary, tertiary and complementary colours printed here are not simple diagrams and contain other aspects of colour.

Complementary colours

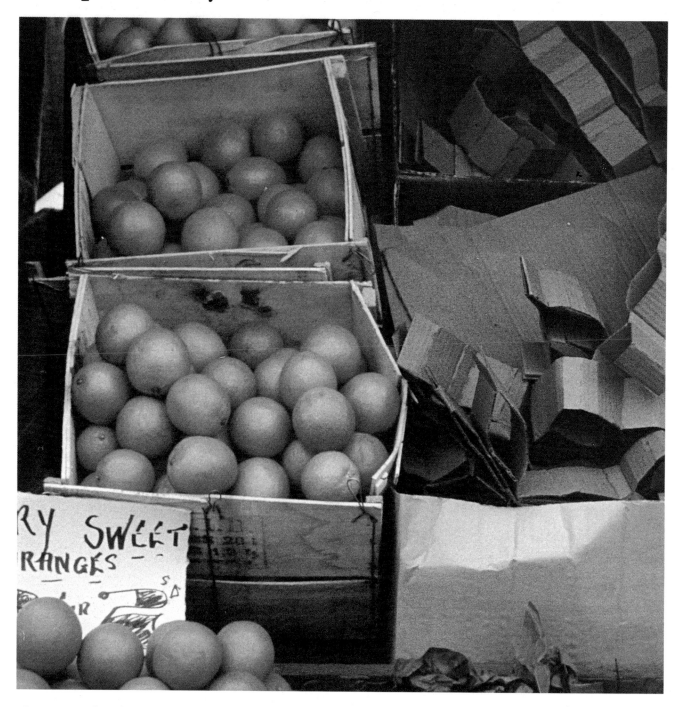

Oranges and packing paper.

Eating House (detail). Harold Gilman. *c.*1914. Oil on canvas. 57.2 × 74.8 cm. Sheffield City Art Gallery.

Local colour

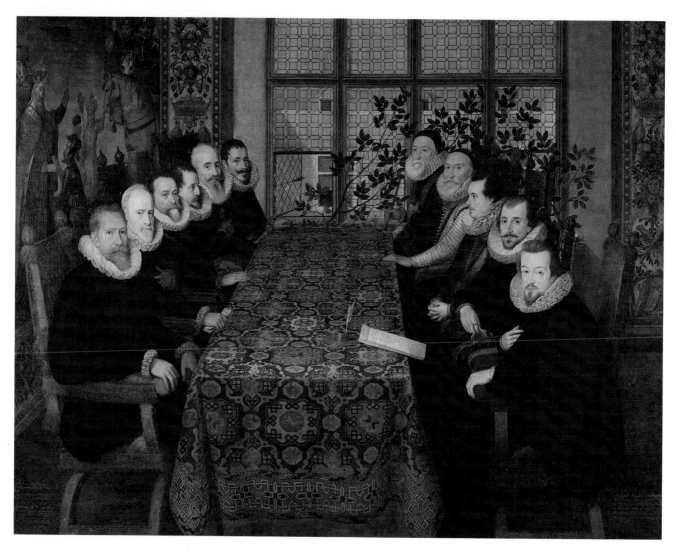

The Somerset House Conference. Unknown (probably Flemish) artist. 1604. Oil on canvas. 205.7 × 268 cm. National Portrait Gallery, London.

Light colour

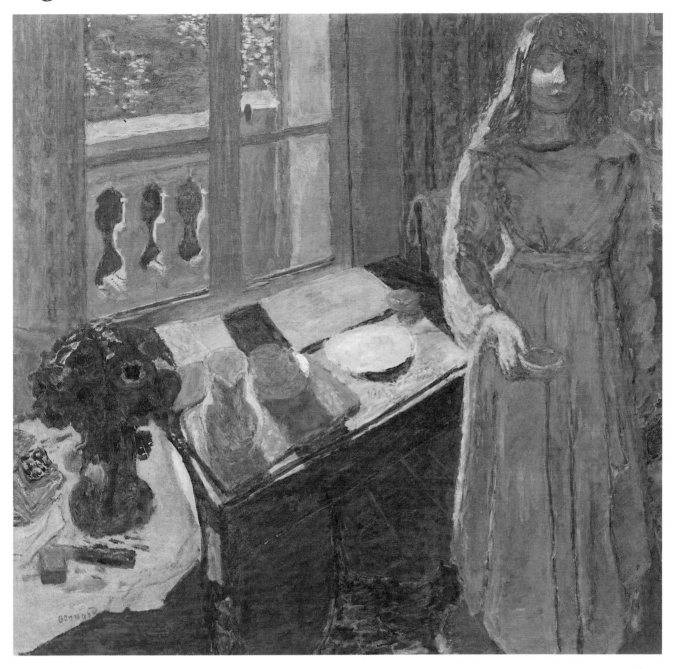

The Bowl of Milk. Pierre Bonnard. *c*.1919. Oil on canvas. 116.2 × 121 cm. The Tate Gallery, London.

Warm colour keys

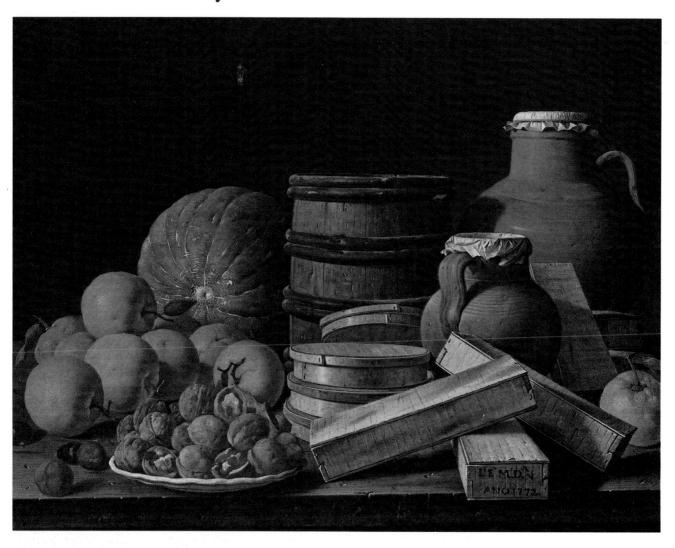

Still-life with Oranges and Walnuts. Luis Melendez (1716–1780). Oil on canvas. 61 × 81 cm. The National Gallery, London.

Cool colour keys

Umbrella workshop. Chiang
Mai, Thailand.

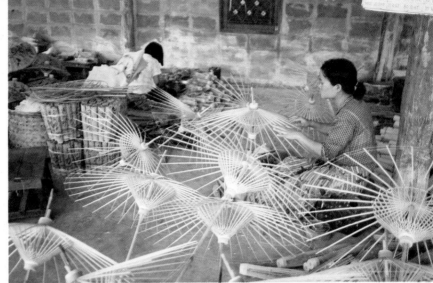

Paddy Fields near Ubud, Bali.
W. Rana. 1986. Oil on canvas.
39 × 29 cm. Private collection.

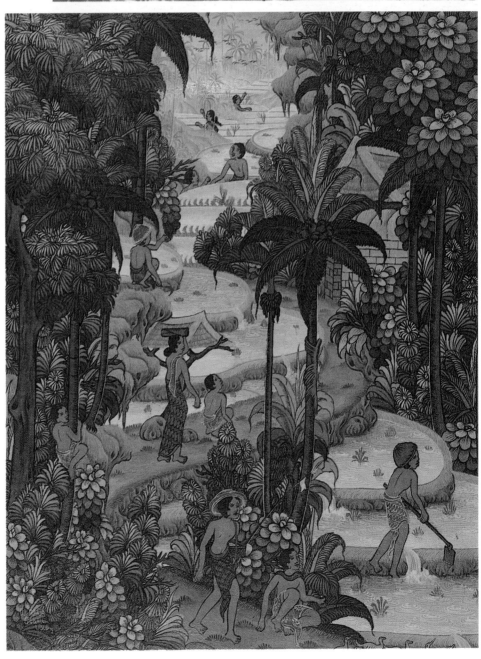

High colour keys

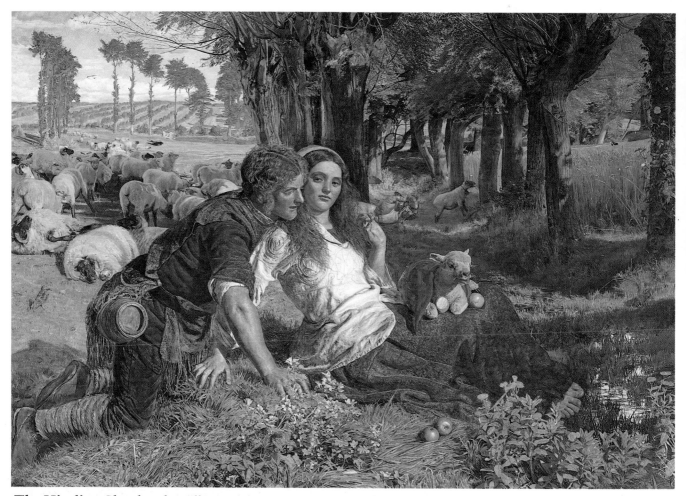

The Hireling Shepherd. William Holman Hunt. 1851. Oil on canvas. 76 × 108 cm. Manchester City Art Galleries.

Low colour keys

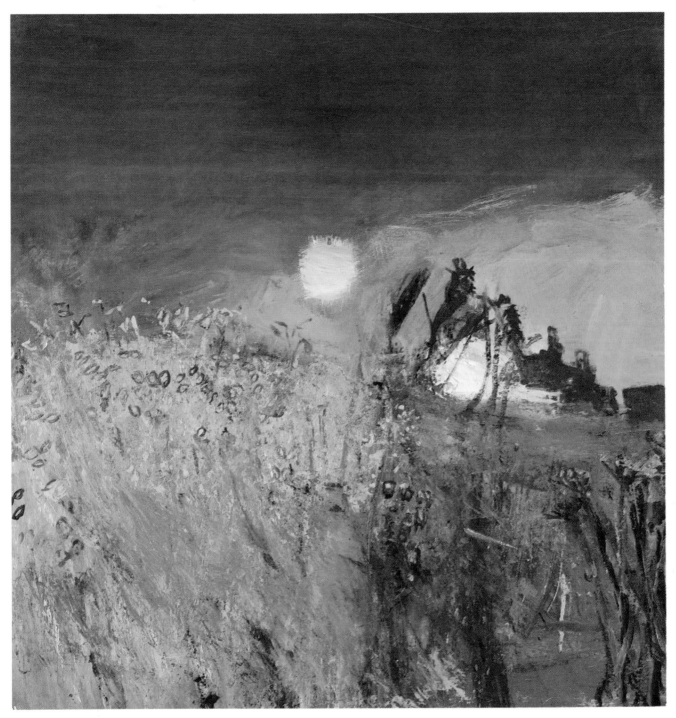

A Field of Oats. Joan Eardley. 1962. Oil on board. 100.2 × 96.7 cm. Arts Council Collection.

Greys

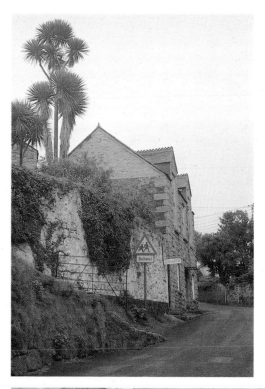

Photograph of School near
Mousehole, Cornwall.

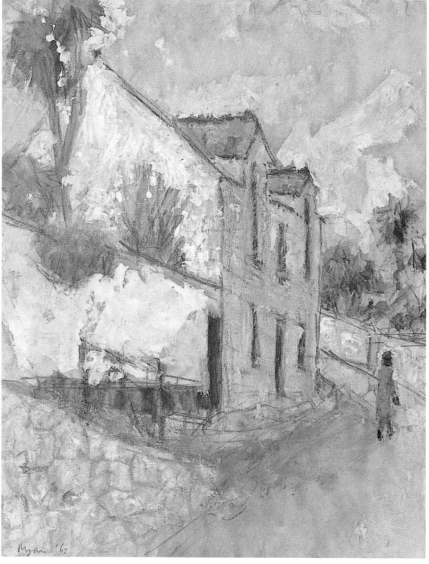

**School near Mousehole,
Cornwall.** Adrian Ryan. 1962.
Pencil, watercolour, pastel
gouache and oil on paper.
25 × 19 cm. Private collection.

Limited palettes

Illustration to *Beauty and the Beast*. Edmund Dulac. 1910. Pen and ink, watercolour. 28 × 20 cm. Victoria and Albert Museum, London.

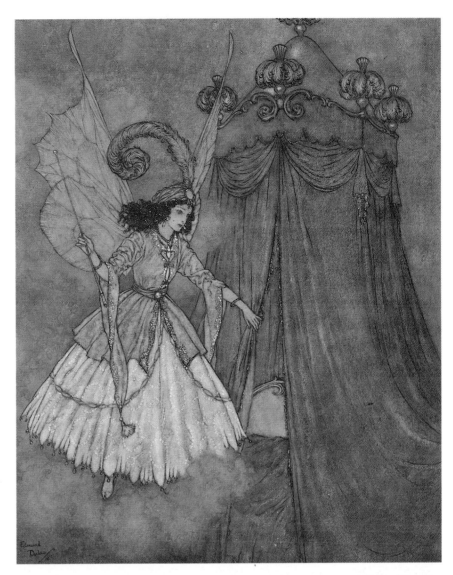

Toledo and River Tajo. David Bomberg. 1929. Oil on canvas. 58.7 × 76.2 cm. Oldham Art Gallery.

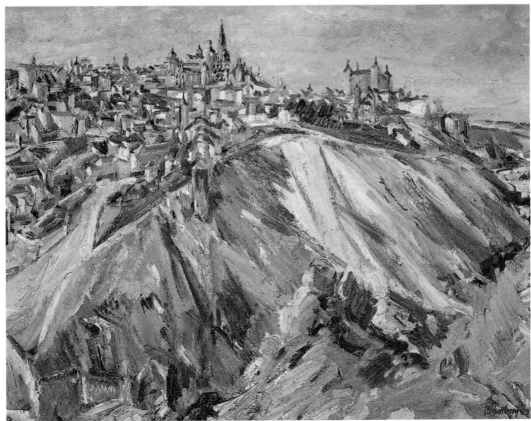

Symbolism

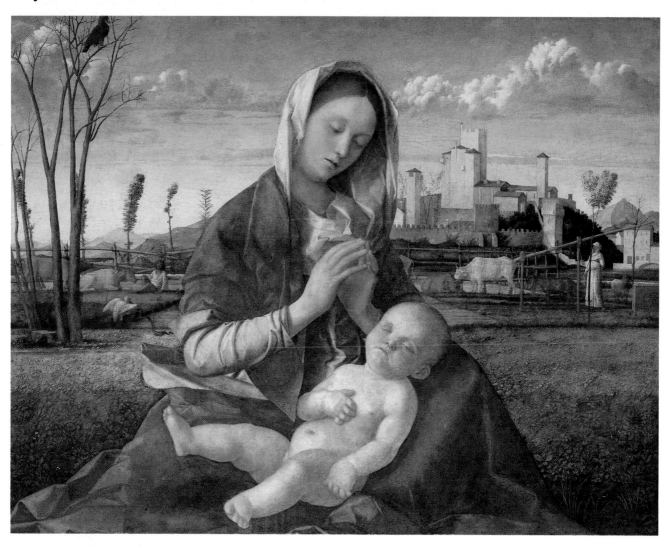

Virgin Mary: The Madonna of the Meadow. Giovanni Bellini (active *c.*1459) Transferred from panel, painted surface. 67.3 × 86.4 cm. The National Gallery, London.

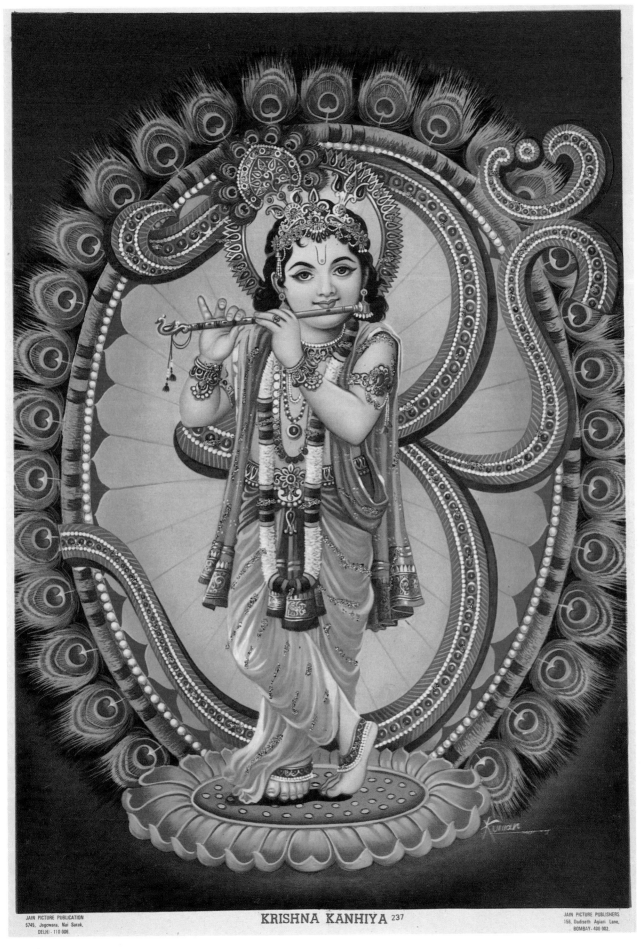

JAIN PICTURE PUBLICATION
5745, Jogewara, Nai Sarak,
DELHI - 110 006.

JAIN PICTURE PUBLISHERS
156, Dadiseth Agiari Lane,
BOMBAY - 400 002.

KRISHNA KANHIYA 237

Krishna.

Decoration or communication?

Devil mask. Bolivia. Twentieth century. 61 cm. Horniman Museum, London.

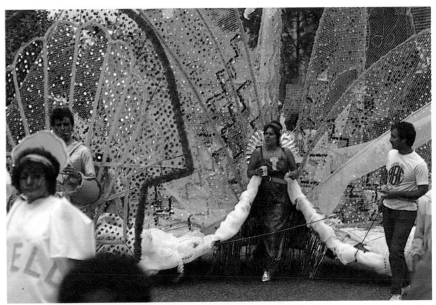

Above: Punk hair style.
Photograph by Sally and Richard
Greenhill.

Above right: Caribbean carnival
costume. Photograph by Sally
and Richard Greenhill.

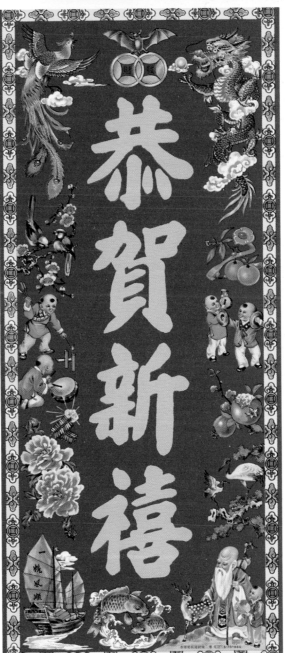

Chinese New Year greetings
poster.

Black and white – the negatives

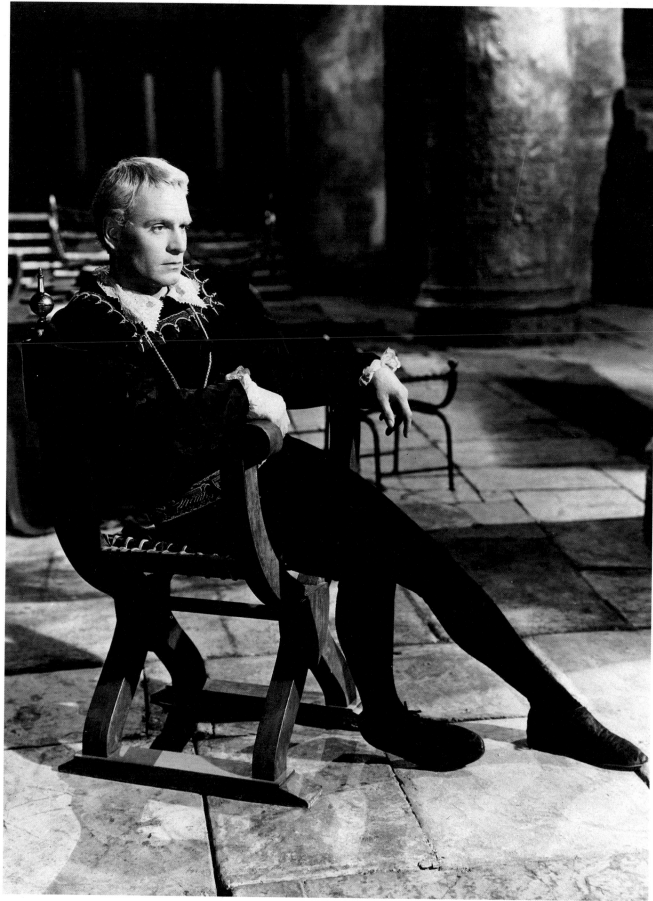

Hamlet. Photograph of Sir Laurence Olivier. Harry Gillard. 1949. British Film Institute at the National Portrait Gallery.

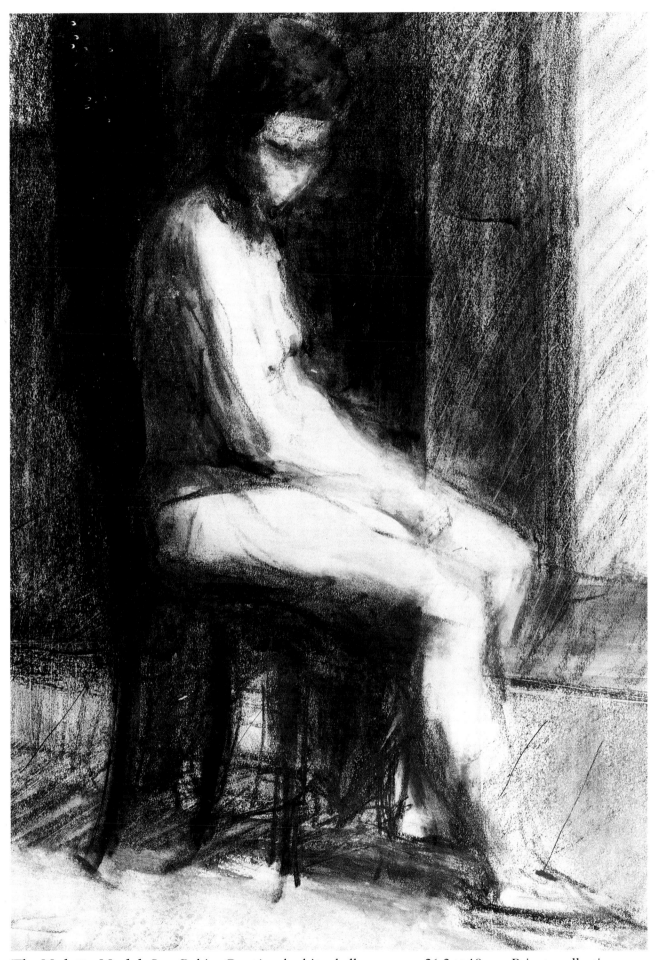

The Mulatto Model. Sam Rabin. Conté and white chalk on paper. 26.2 × 19 cm. Private collection.

Negative colour

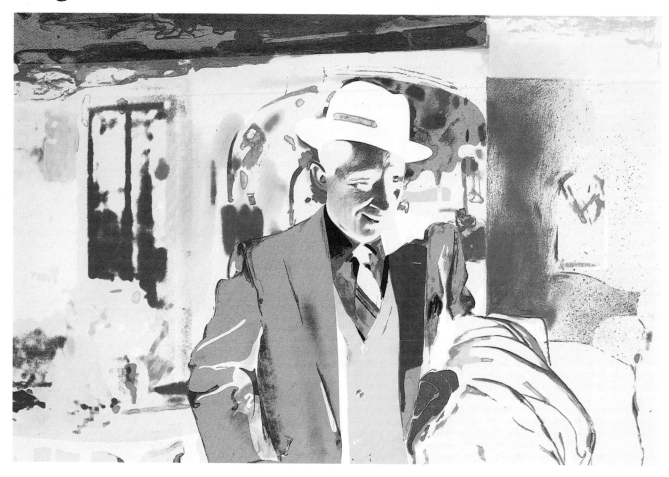

I'm Dreaming of a White Christmas. Richard Hamilton. 1967. Screenprint. 76.5 × 104.4 cm. Waddington Graphics.

Pattern

Pattern may be the repetition of similar lines, shapes, forms, tones or colours; similar but not always identical. Nature's patterns are functional, created for attraction or disguise, the strength of structure, the convenience of storage, or other motives necessary for survival.

Man-made patterns can be either functional or decorative and on occasion a combination of both. There is also that area of pattern which is the composition of a work, its visual rhyme, the repetition of an area, form or colour which makes links across the work.

Regular patterns

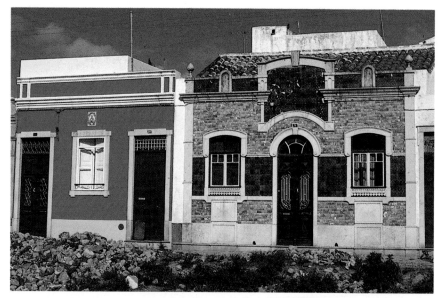

Houses. Faro, Portugal.

St Mark. Illustration from a seventeenth-century Ethiopian manuscript of the Four Gospels. The British Library, London.

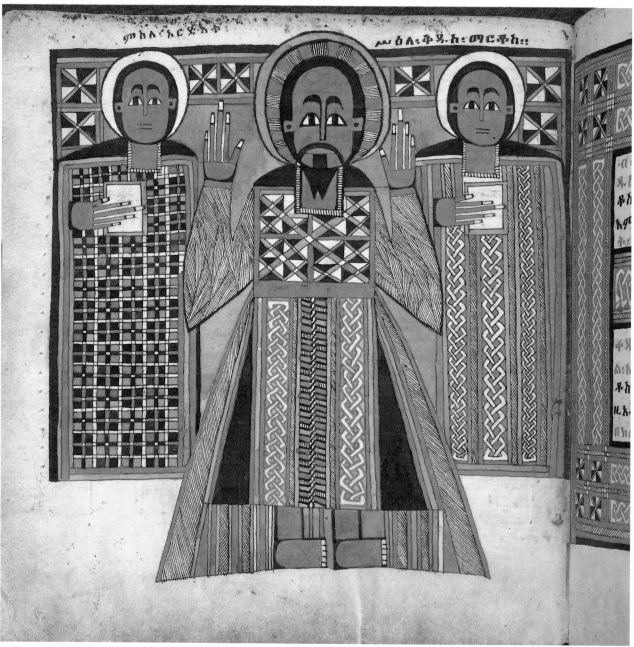

Irregular patterns

Decorated Victorian box.
19 × 19 cm.

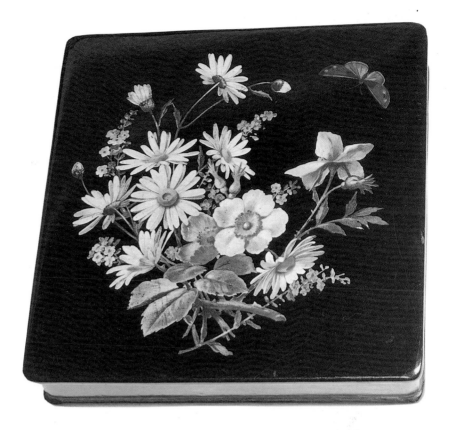

Bellrope Meadow. Stanley Spencer. 1936. Oil on canvas. 66 × 129 cm. Rochdale City Art Gallery.

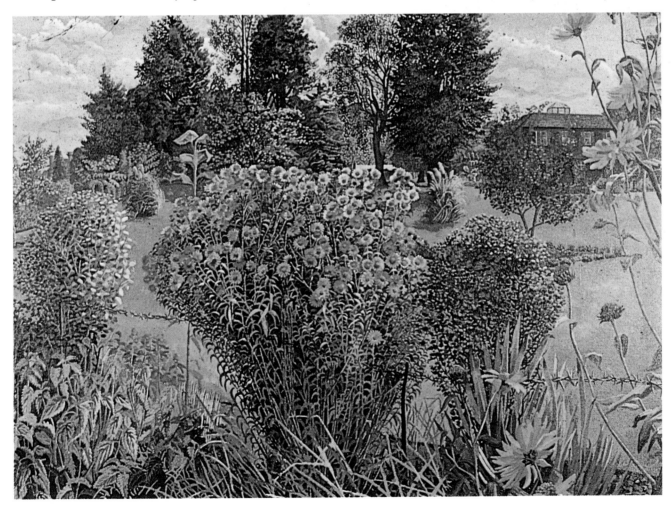

Natural patterns

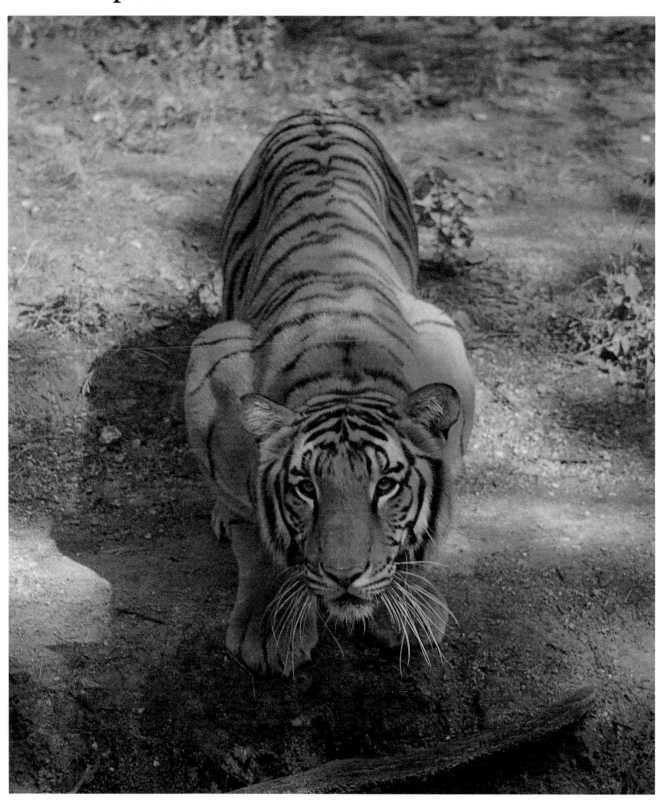

Tiger in natural environment.

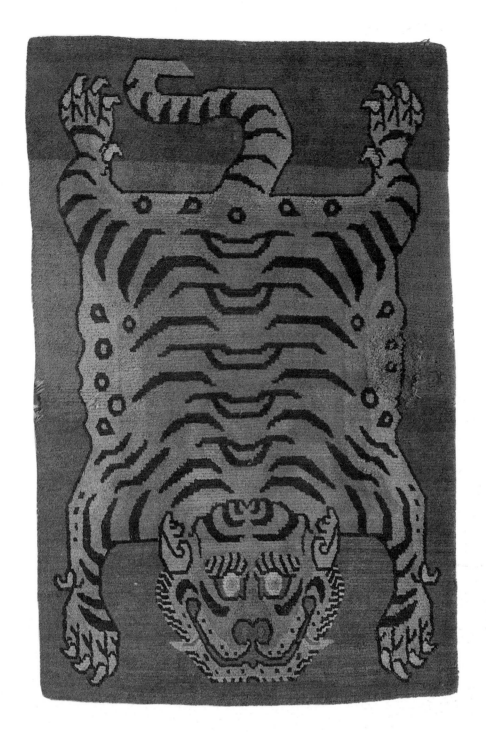

Tiger rug. Nepalese. Early nineteenth century. Wool. Collection of Mimi Lipton.

Man-made patterns

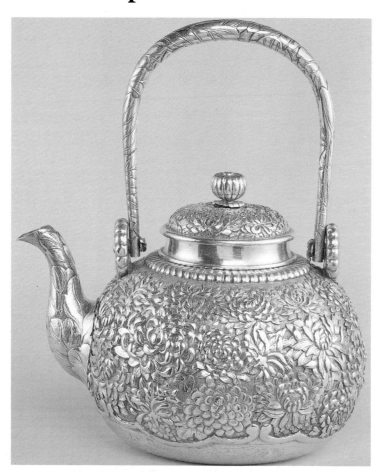

Japanese teapot. Early twentieth century. Silver. 19.6 cm. The Victoria and Albert Museum, London.

Yalkuti, Possum Dreaming Site. Clifford Possum Tjapaltjarri. 1981. Acrylic on canvas. 366 × 229 cm. Collection of Alistair McAlpine.

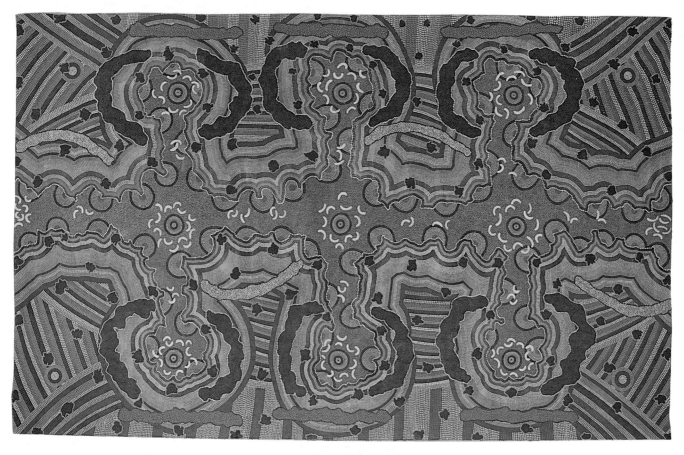

Functional patterns

Spring onions on a market stall.

Building under construction.

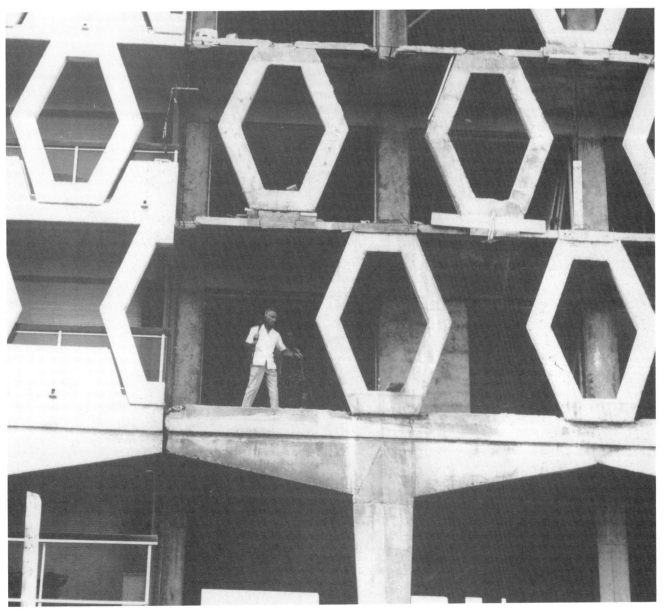

Intentional patterns

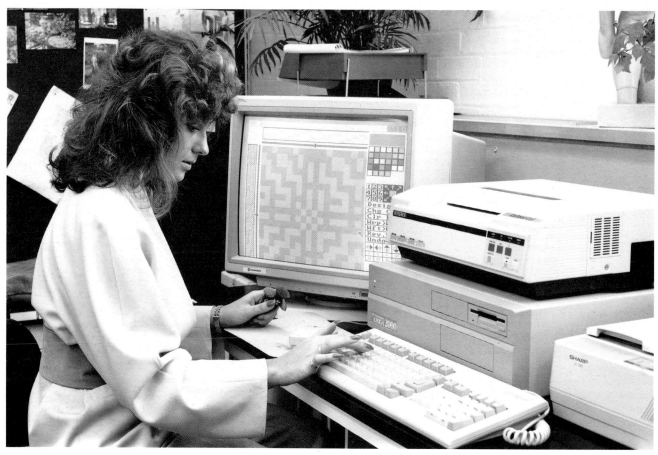

Computer textile designing. Reproduced by kind permission of IWS

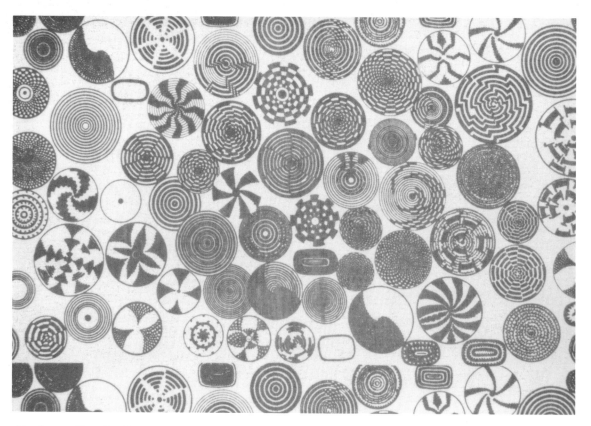

Baskets. Detail of screenprinted cotton from Botswana. Commonwealth Institute.

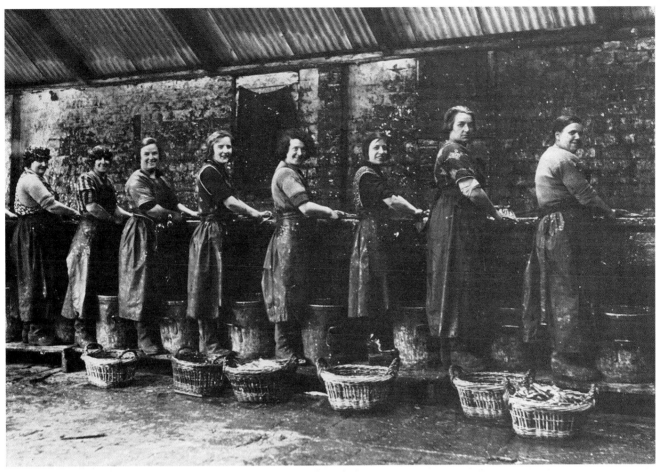

Kipper Girls, Newhaven. James Jarché. 24 September 1931.

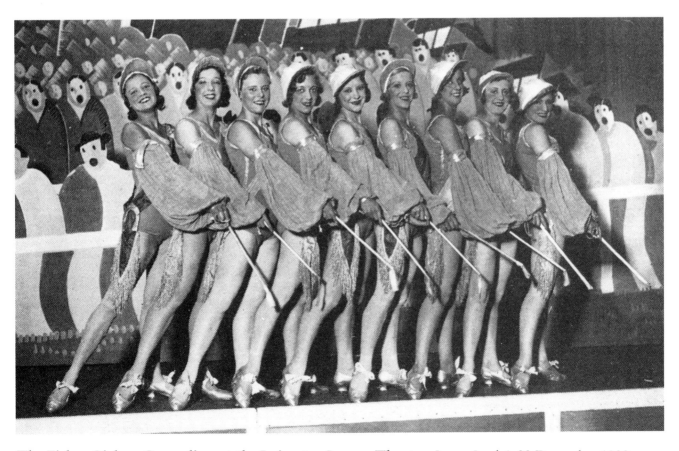

The Fisher Girls as Grenadiers at the Leicester Square Theatre. James Jarché. 22 December 1932.

Unintentional patterns

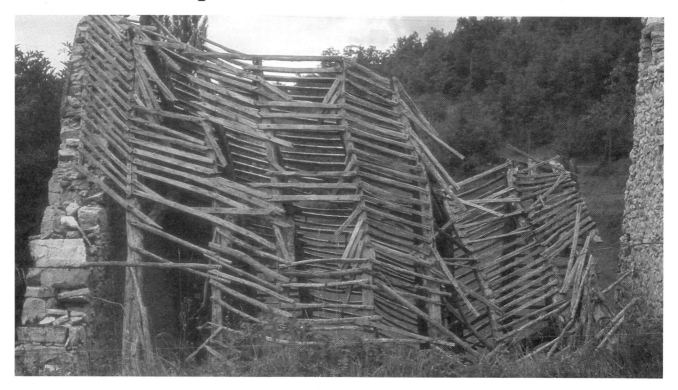

Collapsed building.

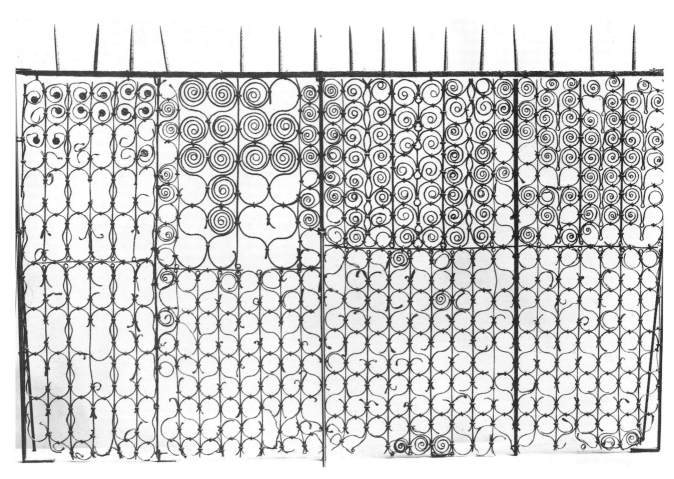

Grille at Chichester Cathedral. Thirteenth century. Wrought iron. Height: 222 cm.

Patterns to attract

Portrait of a Woman. Frans
Hals (*c*.1580–1666). Oil on
canvas. 79.8 × 59 cm. The
National Gallery, London.

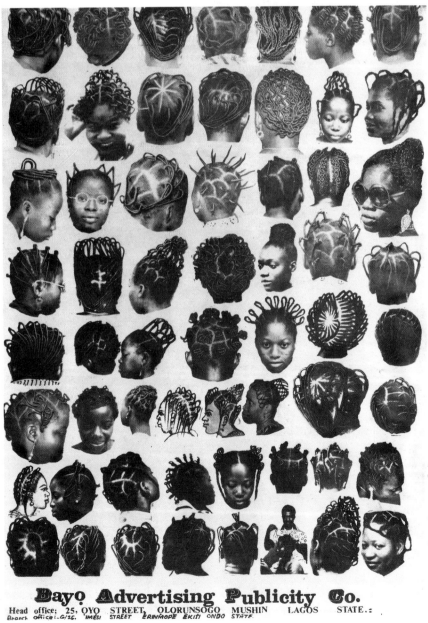

Advertisement for African hair
styles.

Patterns to disguise

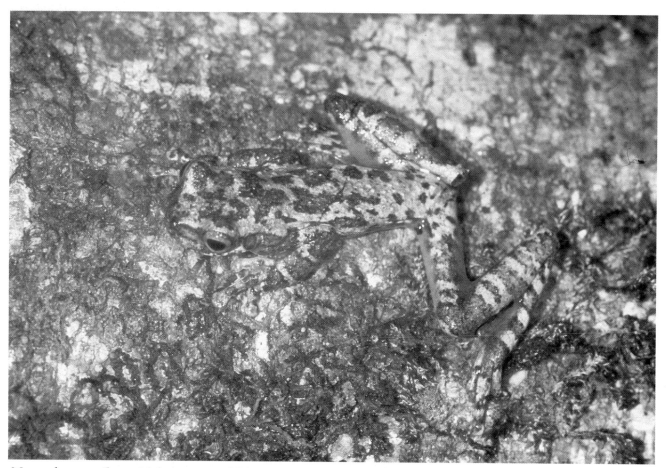

Natural camouflage. Lichen stream frog, cryptic colouration. Monteverde Cloud Forest Reserve, Costa Rica.

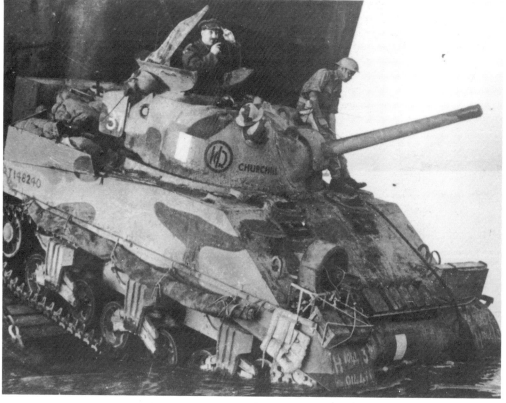

Army camouflage. Tank landing in Sicily, Second World War.

Decoration

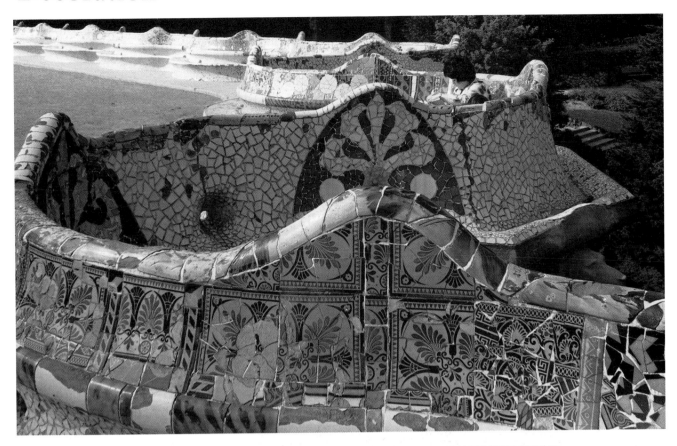

Open air theatre for Parc Guell,
Barcelona. Antonio Gaudi.
1900–14. Photograph by Tim
Benton.

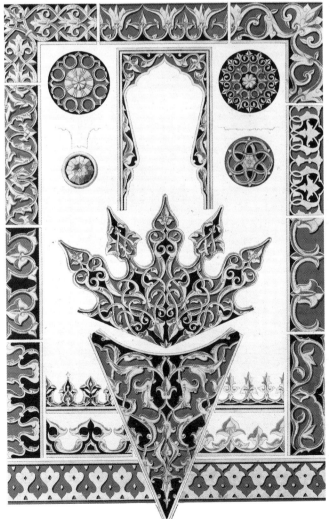

Turkish design. Owen Jones.
1856. Plate 36: *Grammar of
Ornament*.

Communication

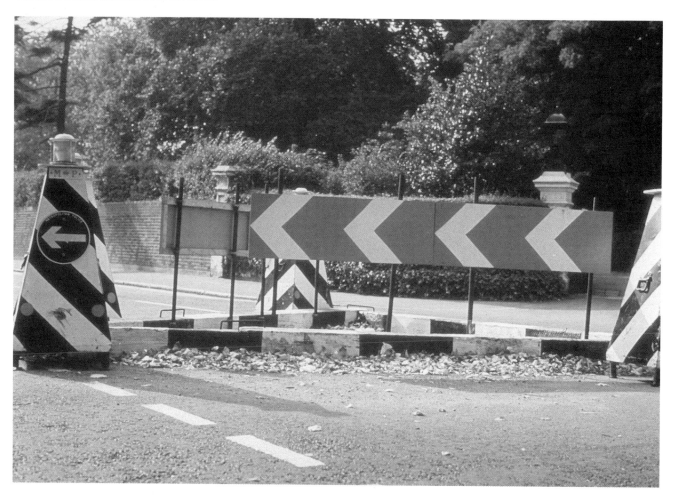

Road signs.

Plan and elevation of Castle Howard, Yorkshire. C.H. Tatham, By kind permission of the Howard Family.

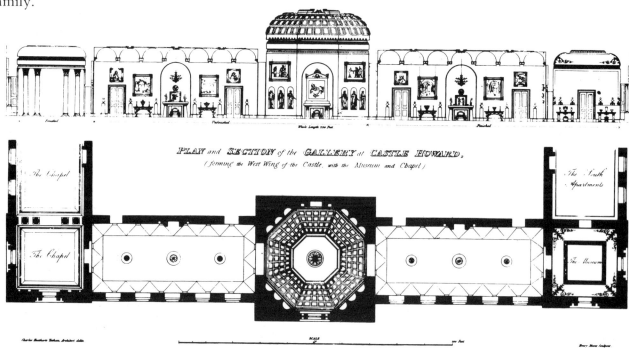

C. H. Tatham, *The Gallery at Castle Howard* (no. 14)

Structural patterns

Traveller's palm.

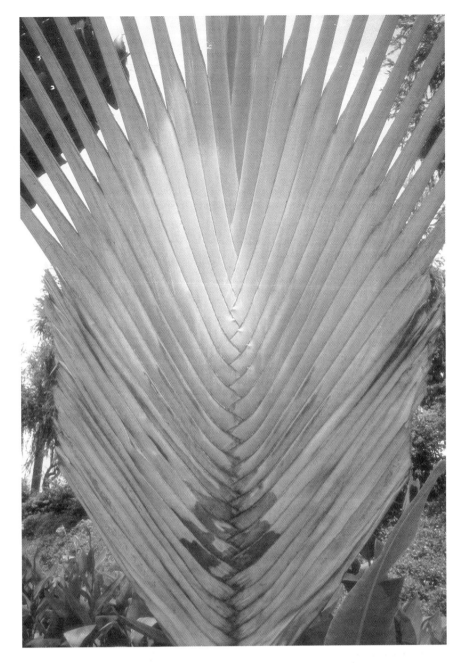

Pyramid building.

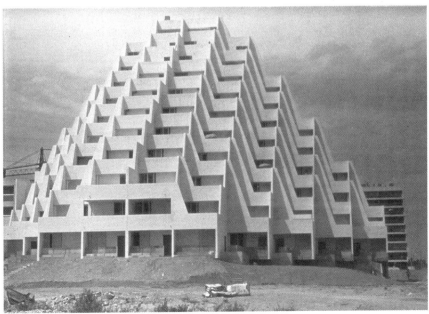

Stacking patterns

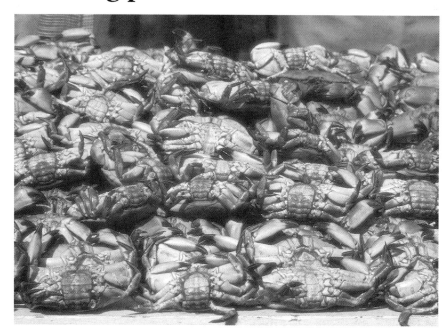

Crabs.

Supermarket trolleys.

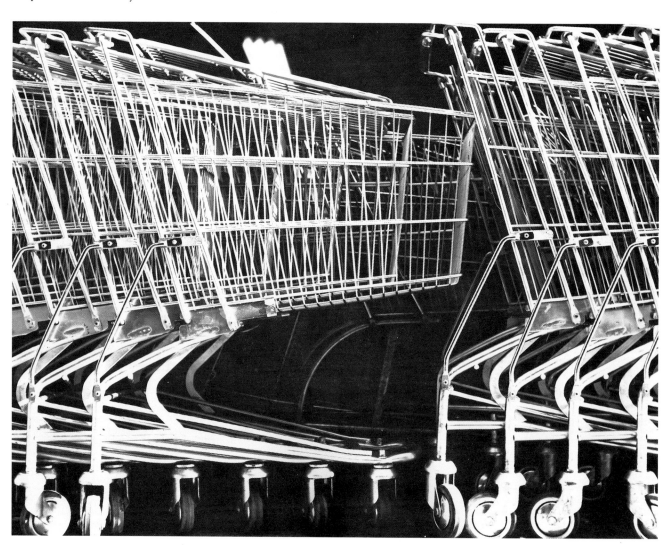

Texture

Often confused with pattern, texture may be related, but is different. There may well be aspects of both in each element, but whereas pattern is the repetition of the similar in either a regular or irregular manner, texture is basically the surface quality of an object, its roughness and smoothness. A surface such as an animal pelt or hide may have a series of shapes and colours which constitute a pattern to attract or disguise but the skin, fur, scale or feathers with which it is composed constitute its texture.

We respond optically to texture, but the texture of smaller objects we can appreciate by touch as well. Other objects, such as the façade of a building, high branches of trees or a landscape, will evoke in us reactions which we relate to touch but which we can only sense through our eyes. Their size and composition make their texture impossible to appreciate in a tactile manner. In addition, there are those textures which alter with time or touch, for example: snow, frost, foam, mud, bubbles and ash.

The artist and designer uses different types of texture to create particular sensations in the viewer or user and may do this by means of verisimilitude or suggestion, reality or ambiguity. These uses of the element are illustrated in this section as well as elsewhere in the book.

Tactile

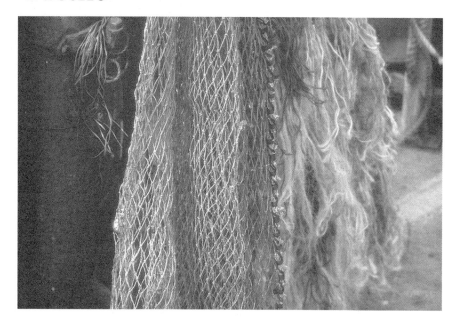

Fishing nets.

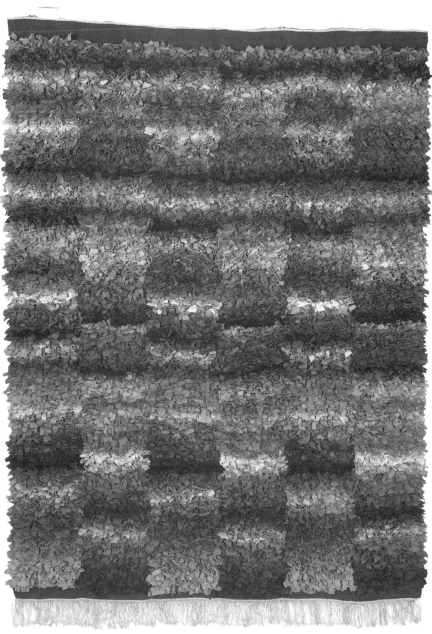

Woven wall hanging. John Hinchcliffe. 1978. Linen warp with woolen weft and cut cotton pile. 2.59 × 1.98 m. The Victoria and Albert Museum, London.

Optical

Marble.

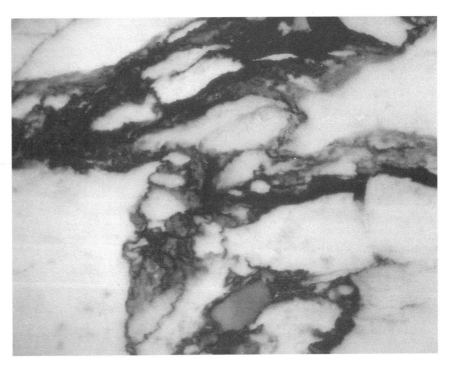

Still-life with Drinking Horn of the St Sebastian Archers. Willem Kalf. *c.*1653. Oil on canvas. 86.4 × 102.2 cm. The National Gallery, London.

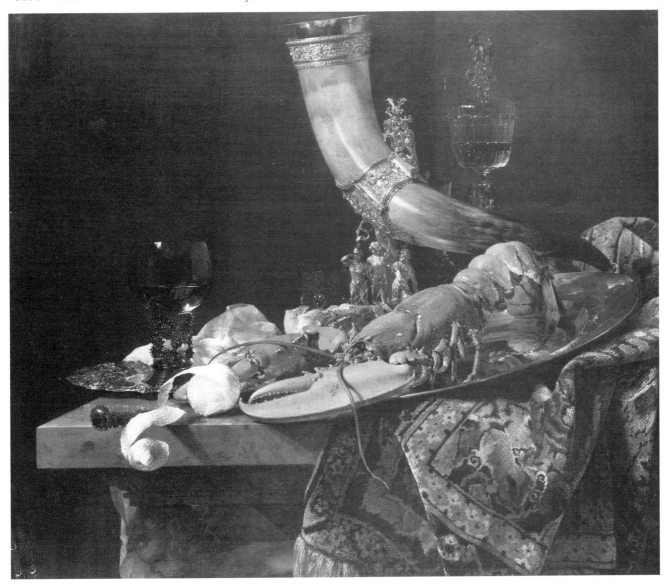

Ephemeral

Foam.

Sand brought to an edge to catch early morning light, Abersock, North Wales. Andy Goldsworthy. 1983.

Tactile
but optical

Beach scene.

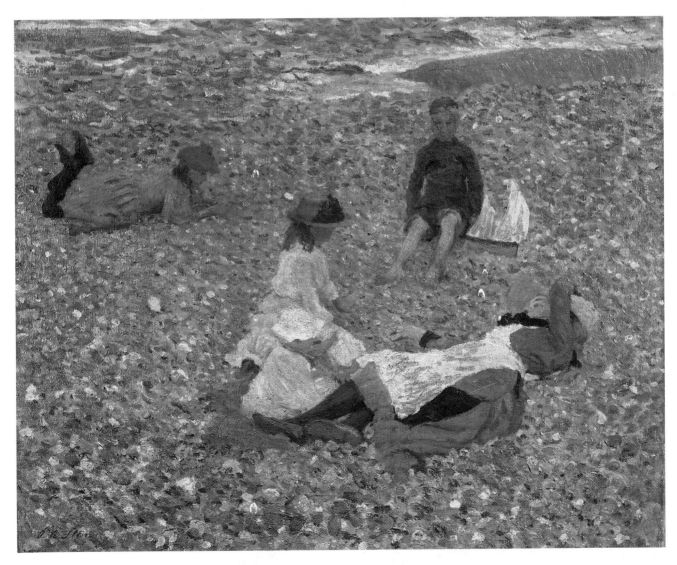

Knucklebones, Walberswick. Wilson Steer. 1888. Oil on canvas. 61 × 76 cm. Ipswich Museum.

Texture as structure

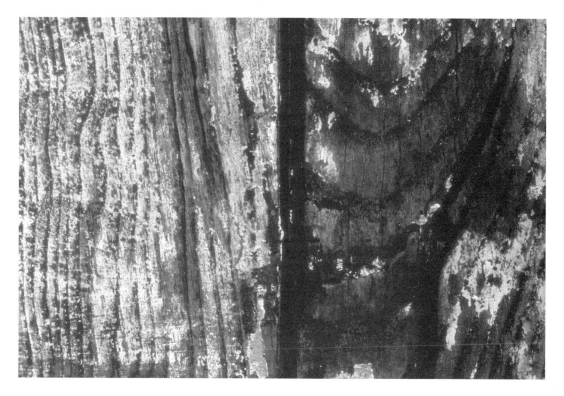

Woodgrain.

Horseman, beaded buckskin dress. Sioux Indian. Late nineteenth century. Height of horse: 13.3 cm. Horniman Museum, London.

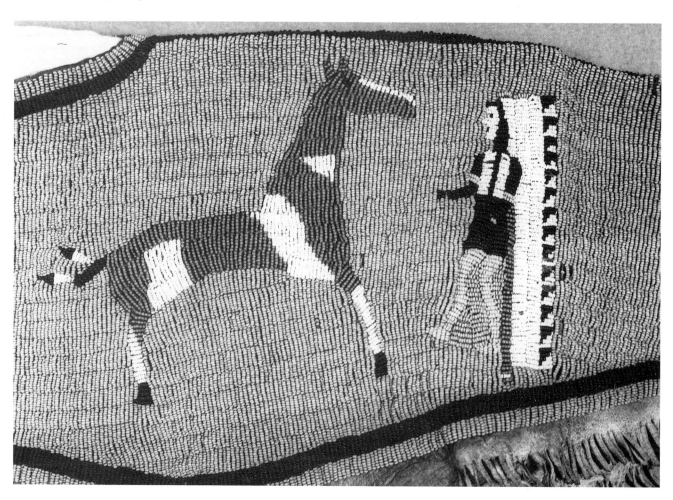

Texture as decoration

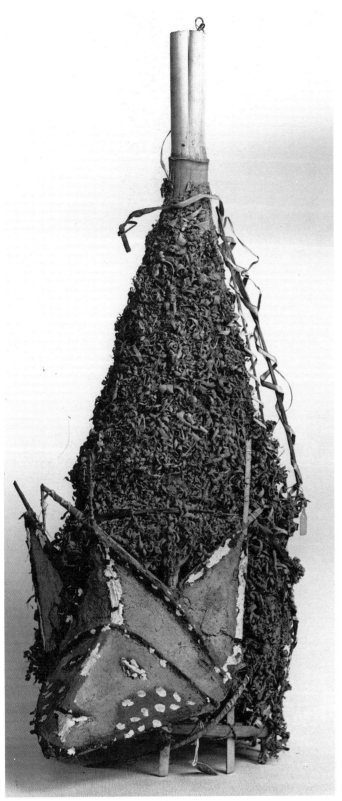

Mask. New Zealand. Painted wood, fibre, plaster, cotton and shell. 32 × 38 cm. Brighton Museum.

Appliqued landscape. *c.*1977.

Texture as communication

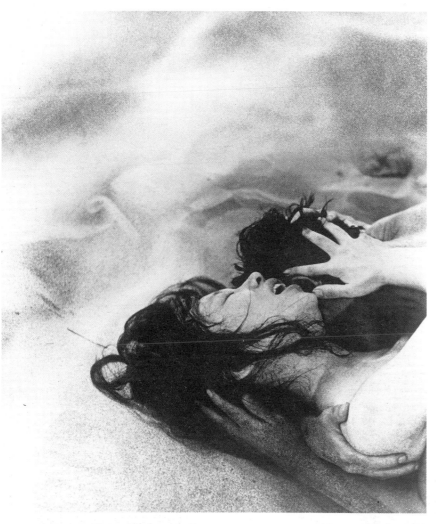

Film still from *Woman of the Dunes*. Hirohi Teshigahara. 1964. National Film Archives.

Fur cup and saucer.
Meret Oppenheim. 1936. Cup: 10.9 cm diameter; saucer: 23.7 cm diameter; spoon: 20.2 cm long; overall height: 7.3 cm. The Museum of Modern Art, New York.

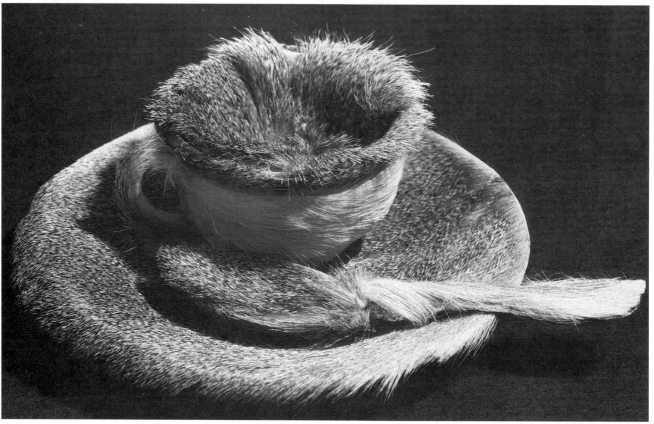

Intentional texture

Castle Acre Priory, Norfolk.
Lith film photograph.

Woman Drying Herself.
Edgar Degas. *c.*1890–95. Pastel
on paper. 64.8 × 63.5 cm. The
National Gallery of Scotland.

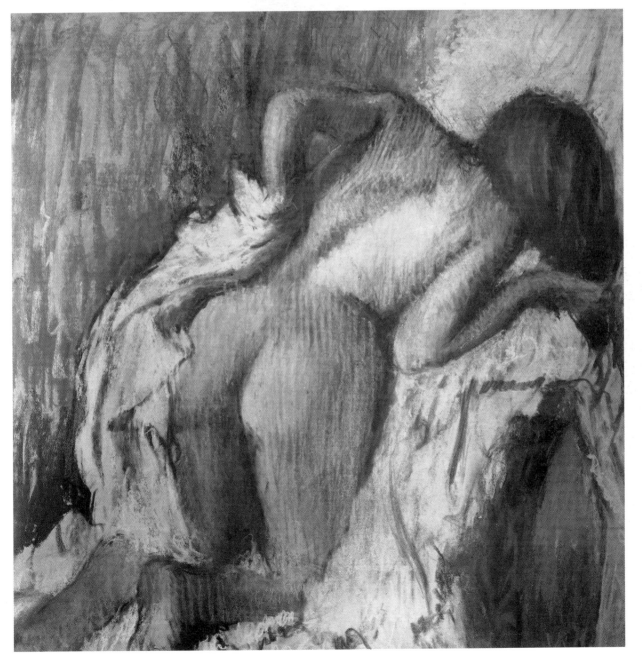

Intentional texture

Left: Detail of sculpture by Henry Moore.

Below left: Detail of wall.

Below middle: Scum on the surface of a pond.

Below right: Broken gravestone.

Bottom of page: Torn posters.

Unintentional texture

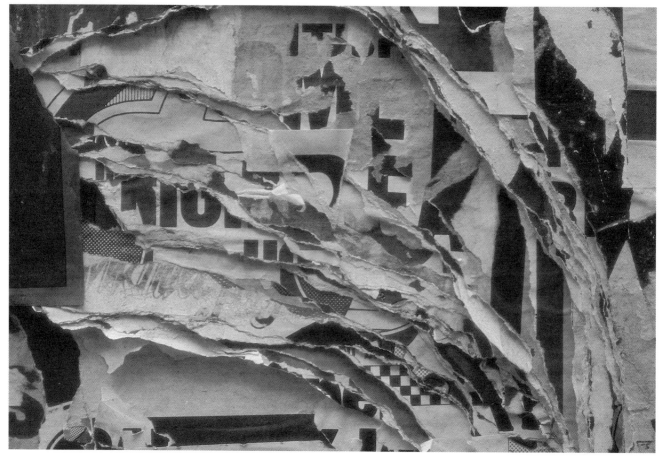

Form

This section has been divided into two-dimensional and three-dimensional form. The illustrations in the first part indicate ways in which the three-dimensional may be represented on a two-dimensional picture-plane, and the relationship between form and some of the means of depiction. Also shown are a number of the practices which make this possible. Obviously, only a limited number of ways of dealing with form can be illustrated and in order to avoid undue repetition the reader is referred to the other illustrations in this book for examples of those aspects of form which relate to visual composition and structure.

The second part of this section gives examples of three-dimensional forms as an *aide-memoire* for the consideration of other areas of the topic which the student will need to investigate.

Two-dimensional form

The depiction of form through line

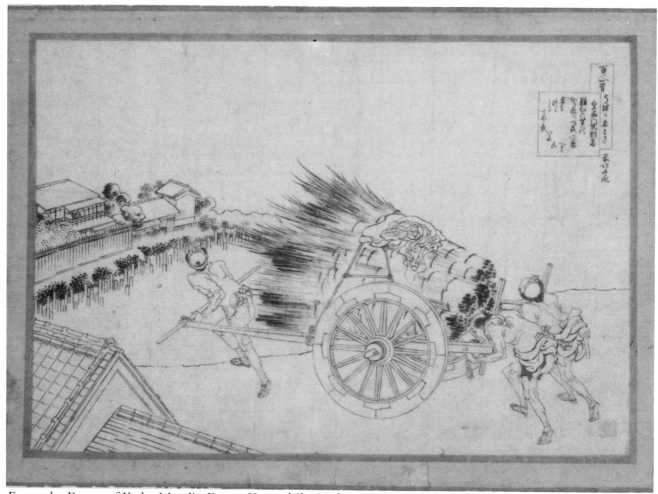

From the Poem of Koka Mon'in Betto. Katsushika Hokusai. *c*.1840. Ink sketch on paper. 29.5 × 40.1 cm. The British Museum, London.

Form through tone

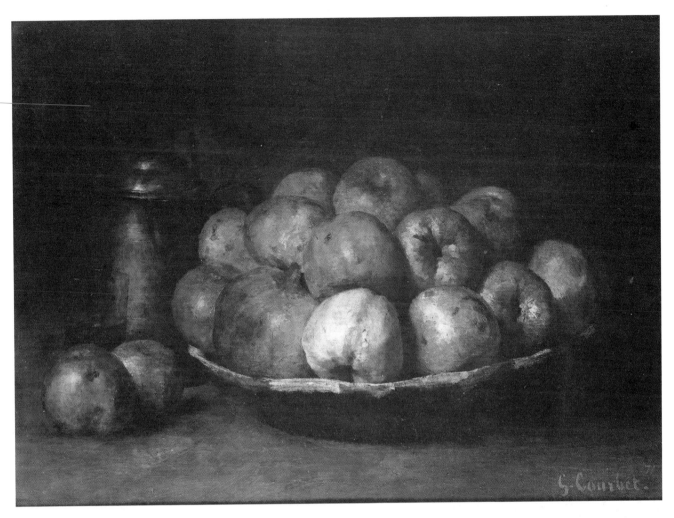

Still-life with Apples and Pomegranate. Gustave Courbet. 1871. Oil on canvas. 44.5 × 61 cm. The National Gallery, London.

Sleep. Edgar Degas. *c.*1885. Monotype: black ink on cream coloured vellum. 29.5 × 40 cm. The British Museum, London.

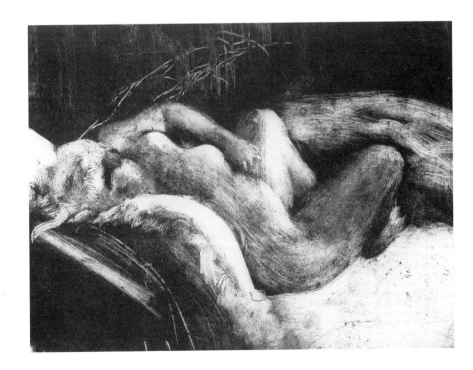

Form through perspective

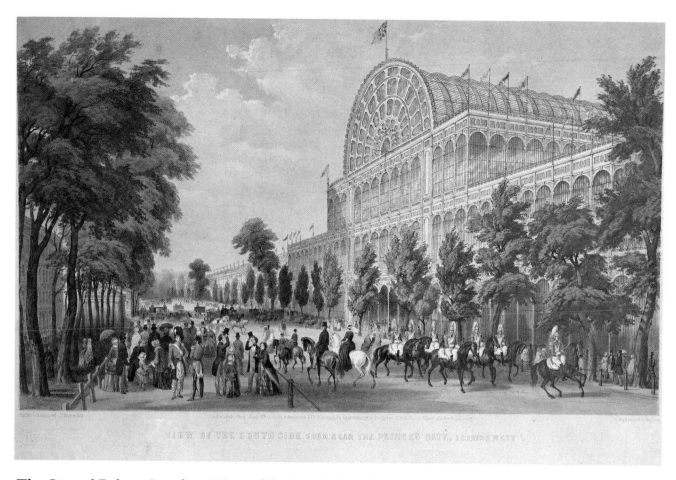

The Crystal Palace, London: View of the South Side from near the Princes Gate, Looking west.
P. Brannon and T. Picken. Lithograph published by Ackermann in 1851. The Guildhall, City of London.

Form through projection systems

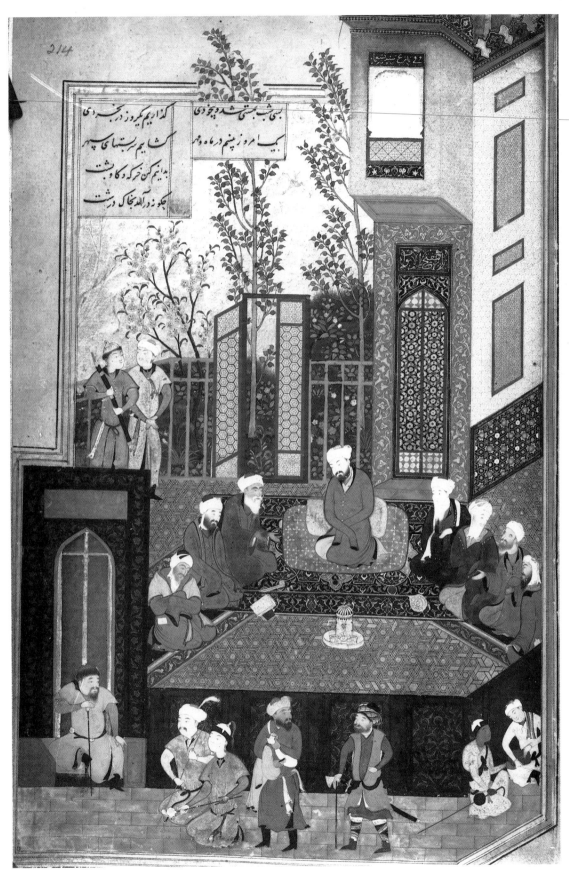

Alexander holding a Council with his Seven Sages. Miniature from Persian manuscript of the *Khamsa* (Five Poems) of Nizāmī. 1494–5. 15 × 24.5 cm. The British Library.

Form through simultaneous viewpoints

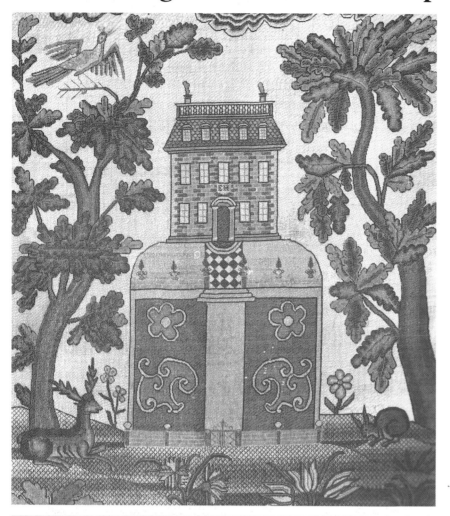

Picture. Elizabeth Haynes. Eighteenth-century English embroidery. Silk on canvas. 35.5 × 32 cm. The Victoria and Albert Museum, London.

This is Sain [sic] Fishery that use to be. Alfred Wallis. Oil and pencil on card. 40.5 × 58 cm. Private collection.

Fruit Dish and Carafe. Juan Gris. 1914. Papier collé on canvas with oil paint and coloured chalks. 92 × 65 cm. Rijksmuseum, Kroller-Muller, Otterlo, Holland.

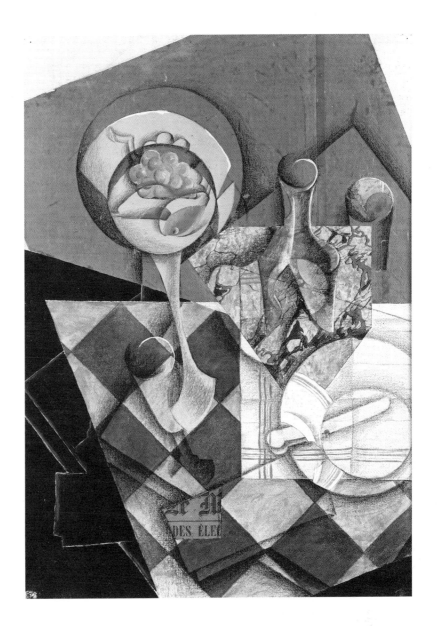

Plan and elevation illustration from car sales brochure: The Dolomite Roadster Coupé, 1938. National Motor Museum, Beaulieu, Hants.

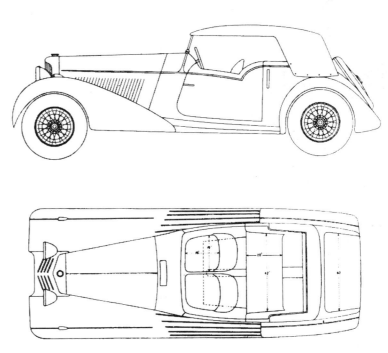

Form in drawing

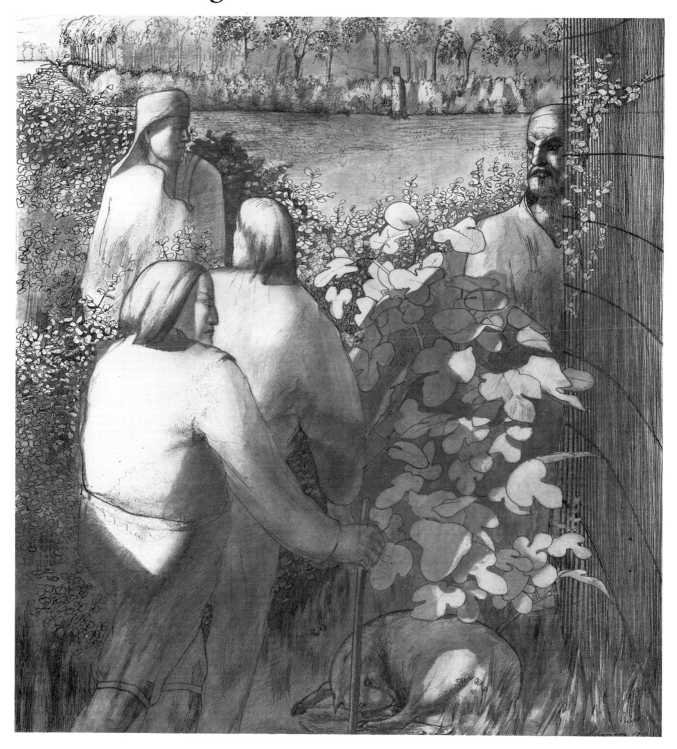

Study for **Joachim among the Shepherds.** Stanley Spencer. 1912. Pen, pencil and wash. 40.5 × 37 cm. The Tate Gallery, London.

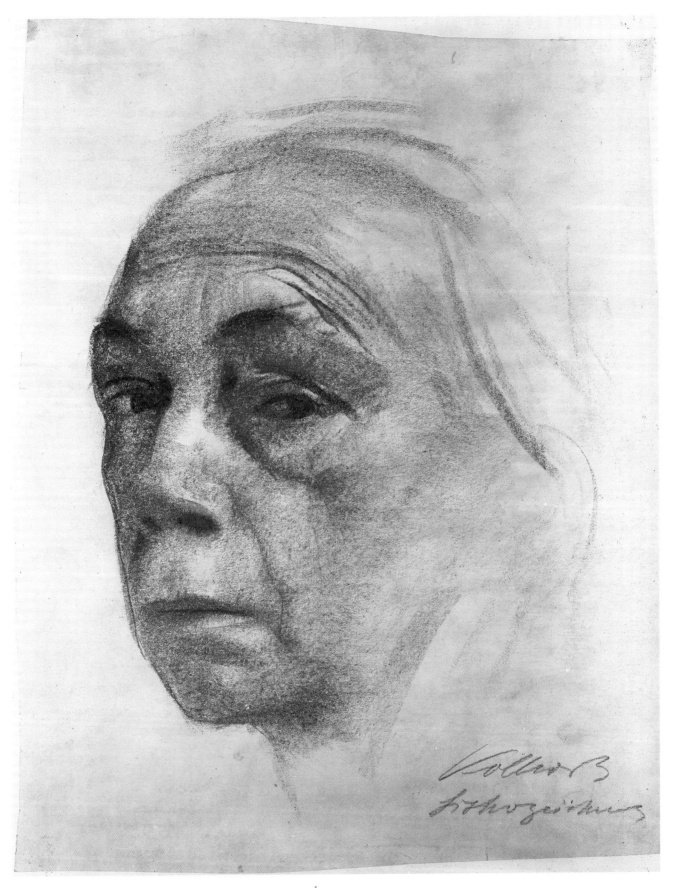

Self-portrait. Kathé Kollwitz. 1924. Lithograph retouched with pencil. 52.8 × 36 cm. National Gallery of Art, Washington, D.C.

Form in painting

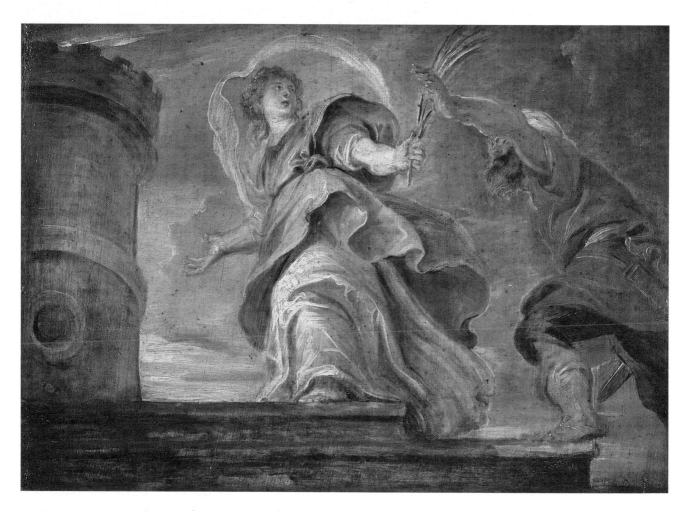

St Barbara fleeing her Father. Peter Paul Rubens. *c.* 1620. Oil on panel. 32.6 × 46.2 cm. Dulwich Picture Gallery.

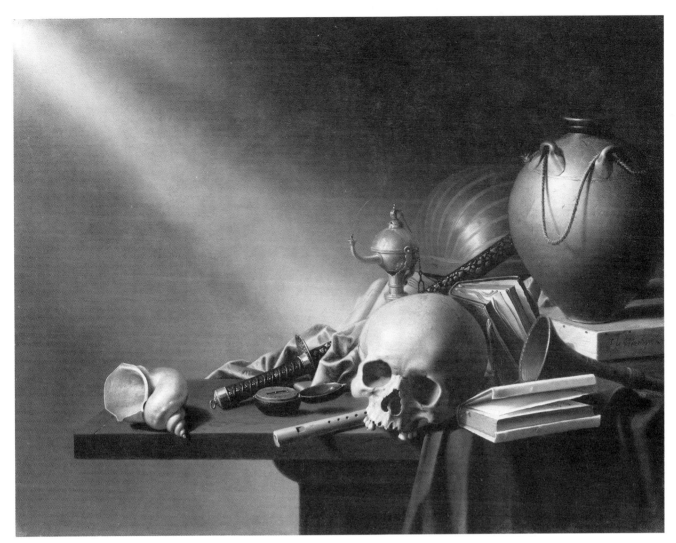

Still-life: An Allegory of the Vanities of Human Life. Harmen Steenwyck (1612–after 1655). Oil on panel. 39.2 × 50.7 cm. The National Gallery, London.

Form in printmaking

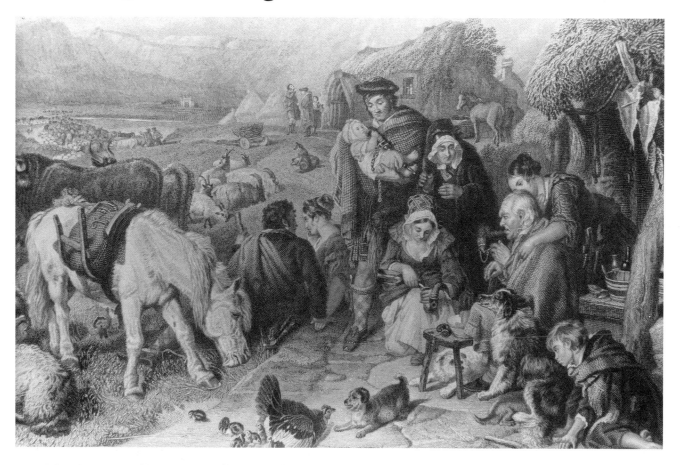

Highland Scene. Engraving. Collection of A. Dyson

Form in photography

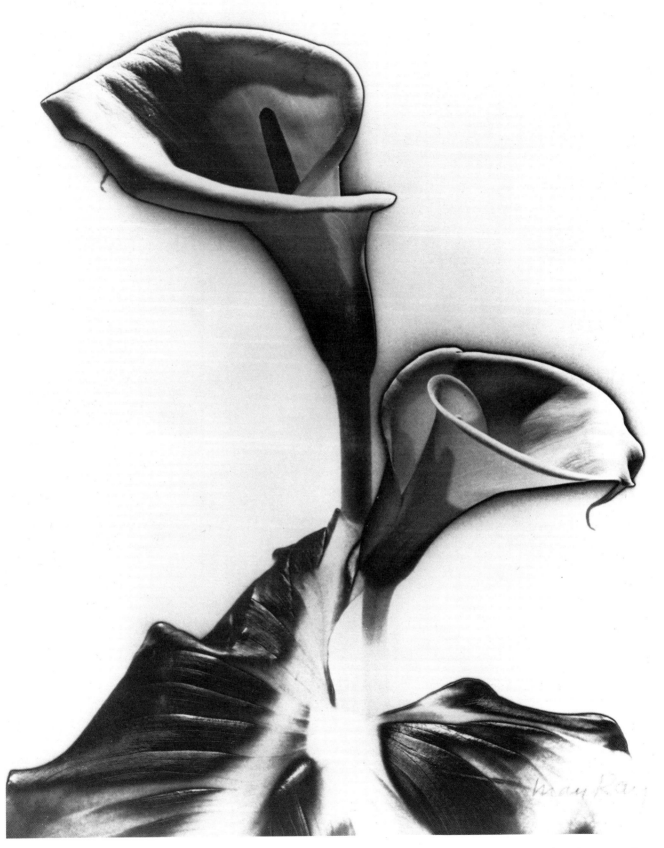

Lilies. Man Ray. Solarised photograph. Collection of the J. Paul Getty Museum, Copyright 1976 Man Ray Trust/ADAGP-Paris/ARS USA.

Form in computer graphics

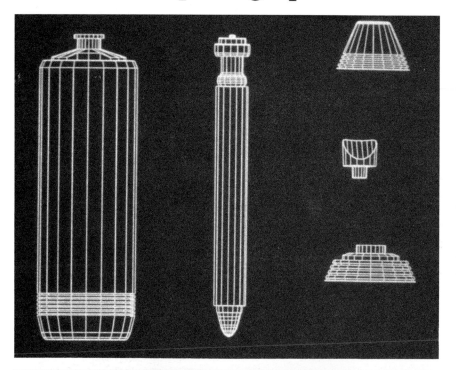

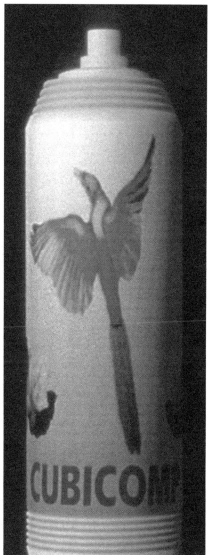

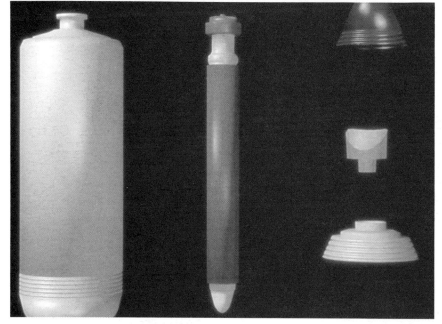

Sequence of three slides showing the development from line to solid form. Produced on the Picturemaker System by Cubicomp Corporation.

Three-dimensional form

Relief

Marriage of Siva and Parvati.
Indian Paia. Tenth century.
Stone. 63.5 cm high. The British
Museum, London.

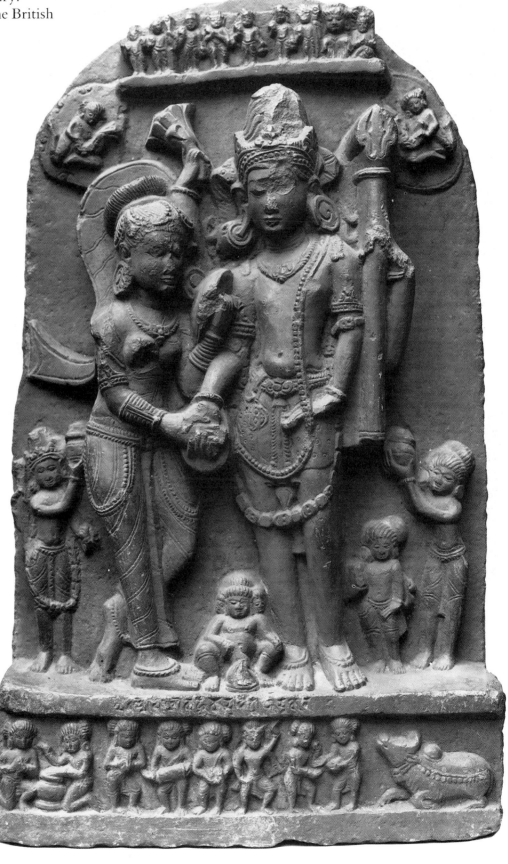

Compound Rhythms. Mary Martin. 1966. Painted wood and stainless steel on wood and formica support. 108 × 108 × 11.4 cm. Waddington Galleries.

The Sacrific of Isaac. Bible cover. Second half of the seventeenth century. Stumpwork. Bodleian Library, Oxford.

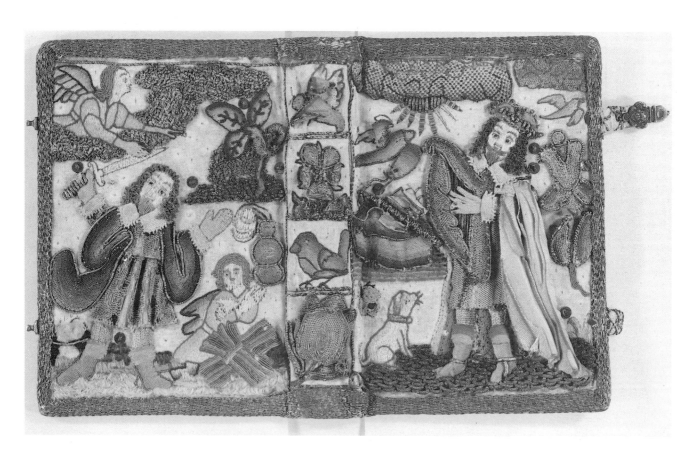

Modelling

George Bernard Shaw. Jacob Epstein. 1934. Bronze. 43 cm. Birmingham City Museums and Art Gallery.

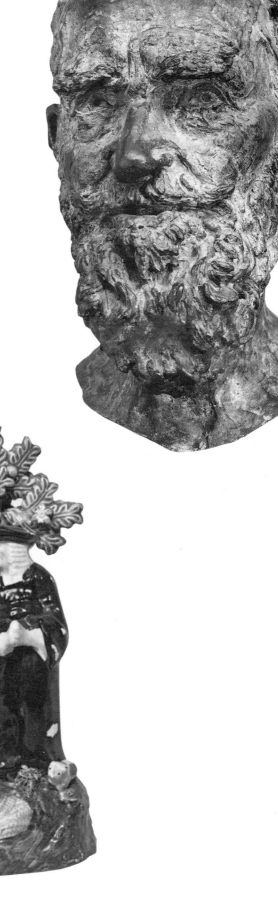

The Tithe Pig. Staffordshire figure group. Early nineteenth century. Ceramic. Hove Museum of Art.

Carving

Keystone showing Samson and
the Lion. 1170–80. Keynsham
Abbey, Somerset.

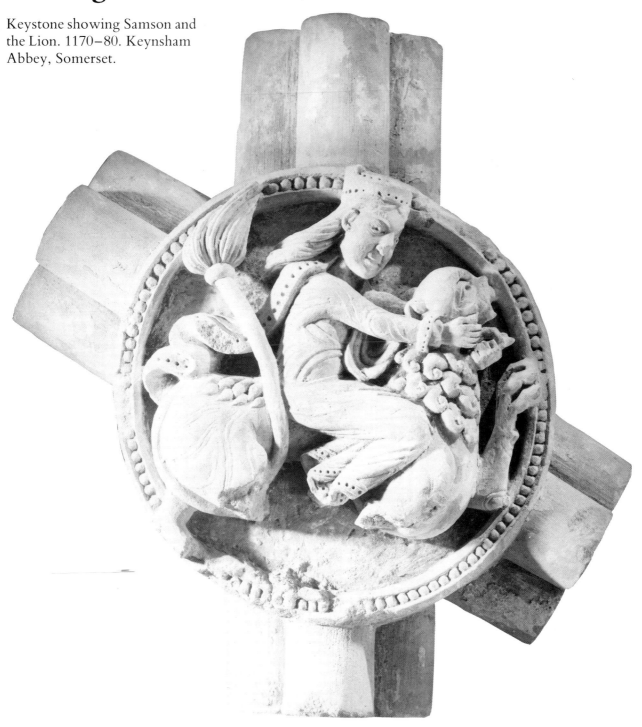

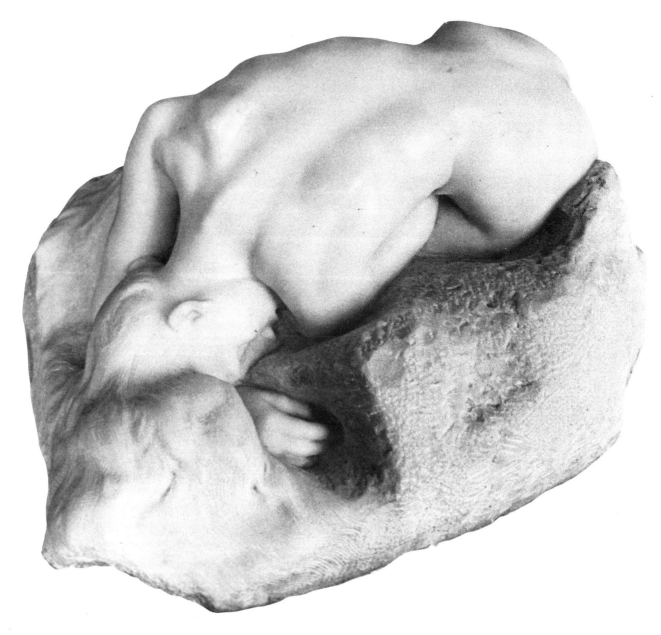

Danaid. Auguste Rodin. 1885. Marble. Musée Rodin, Paris. Photograph by Alex Simm.

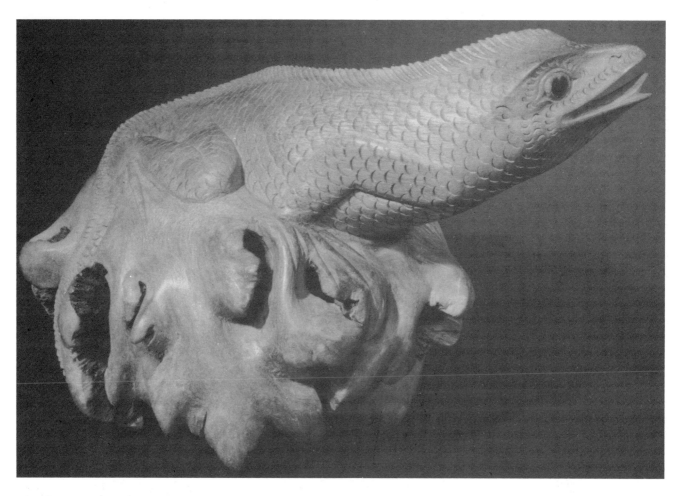

Gecko. Indonesian wood carving. 1985.

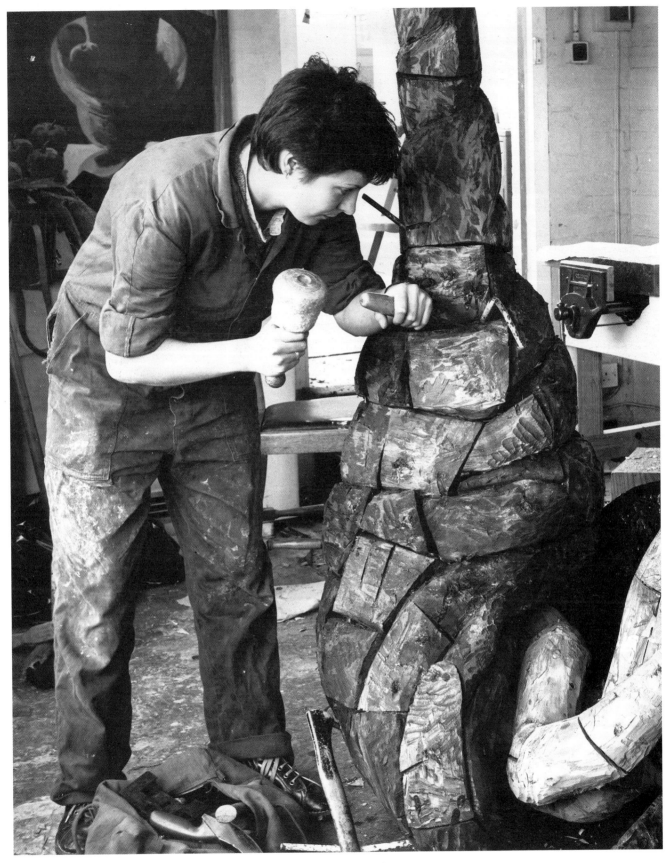

A Spire Shell. Hilary Cartmel. 1982. Photography by Keith Gray.

Construction

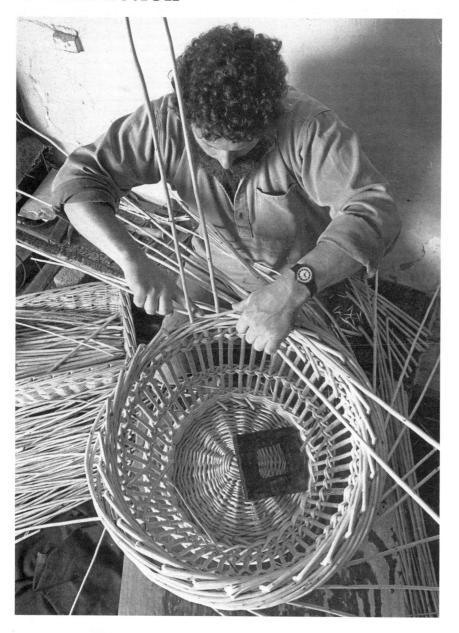

Baskets. David Drew. Crafts Council. Photograph by Chris Chapman.

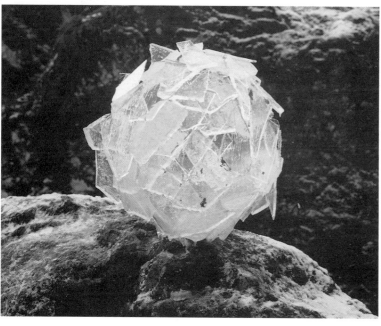

Ice Sculpture. Andy Goldsworthy.

Glass flask. Roman. Third century. The British Museum, London.

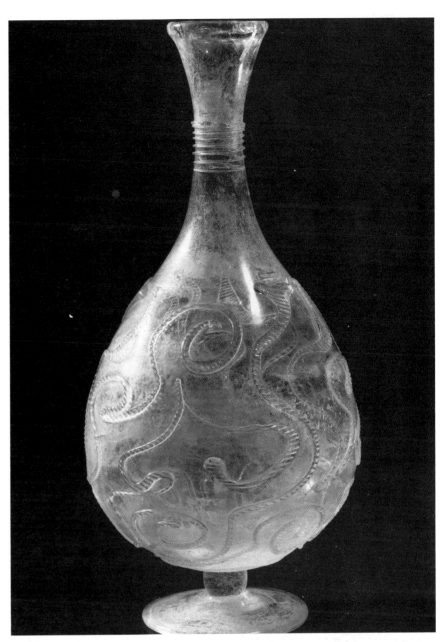

Red–blue chair (replica of 1918 original). Gerritt Rietveld. University of East Anglia.

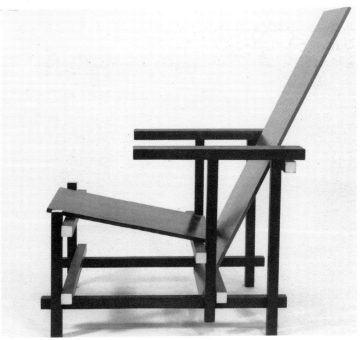

Kinetic sculpture

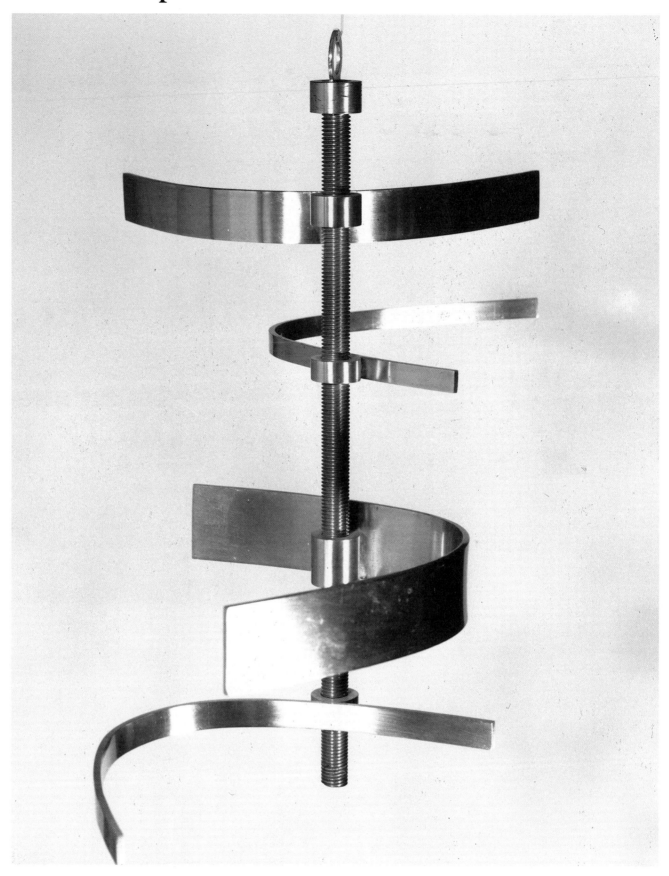

Screw Mobile. Kenneth Martin. 1967. Brass. 35 × 34.5 × 34.5 cm. University of East Anglia.

Soft sculpture

Soft toys.

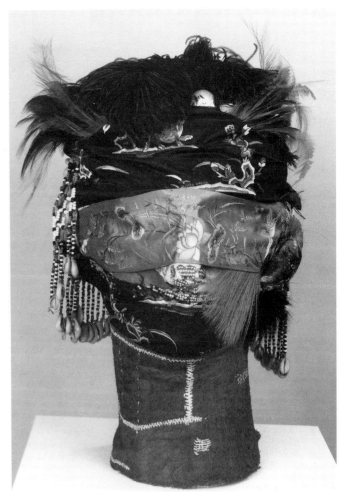

Angel of Anarchy, 3rd View.
Eileen Agar. 1940. Plaster cast
covered with mixed media. 70 ×
30.5 × 30.5 cm. The Tate
Gallery, London.

Architectural forms

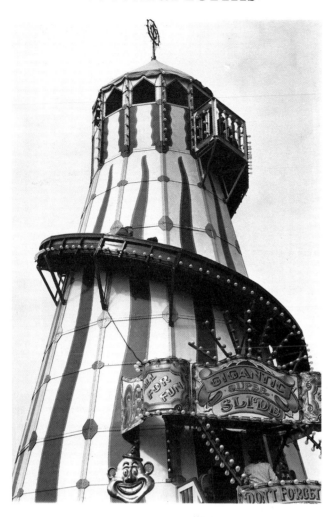

Helter skelter.

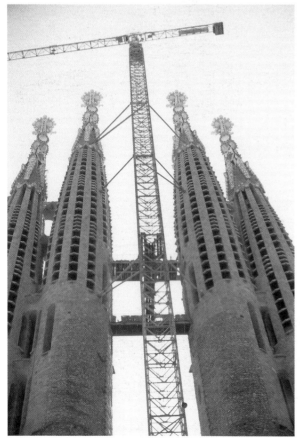

Cathedral of the Holy Family. Barcelona. Antonio Gaudi. Begun 1884.

Form and function

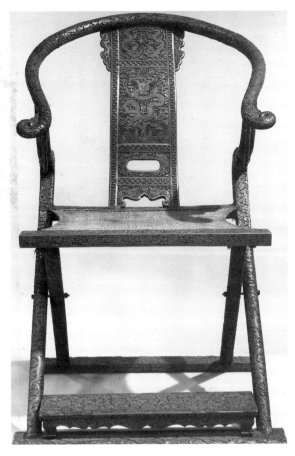

Imperial folding chair. Chinese. Sixteenth century. Red lacquer carved on wood. 91.5 cm. The Victoria and Albert Museum, London.

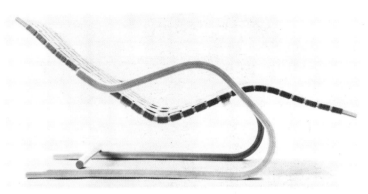

Chaise Longue. Alvar Aalto. 1937. The Victoria and Albert Museum, London.

Silver cruet in the form of the great clown, Joseph Grimaldi with parts of the body removable. Early nineteenth century. The Theatre Museum, The Victoria and Albert Museum, London.

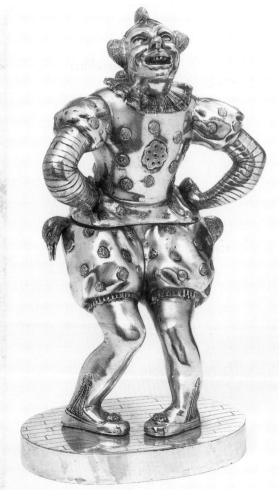

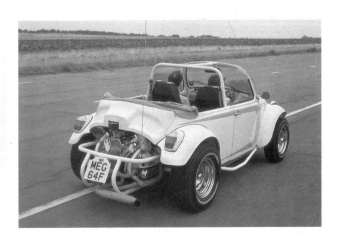

Silver cruet in sections.

Dune buggy. Photograph by Mike Key.

Book List

Dyson, A., *Etching and Engraving: Technique and Tradition*, Longman, 1986.

El-Said, I. and Barman, A., *Geometric Concepts in Islamic Art*, Scorpion, 1988.

Eirwen Jones, M., *A History of Western Embroidery*, Studio Vista 1979.

Gernsheim, H. and A., *A Concise History of Photography*, Thames and Hudson, 1965.

Golding, J., *Cubism*, Faber, 1971.

Kandinsky, W., *Concerning the Spiritual in Art* [and painting in particular], orginally published in 1912. Wittenborn, New York, 1947.

Owen, P., *Painting*, Oxford, 1970.

Palmer, F., *Encyclopaedia of Oil Painting Materials and Techniques*, Batsford, 1984.

Palmer, F., *Themes and Projects in Art and Design*, Longman, 1988

Palmer, F., *Visual Awareness*, Batsford, 1972.

Pevsner, N., *Pioneers of Modern Design*, Pelican, 1974.

Pollock, G., *The Subversive Stitch*, Womens Press, 1984.

Rawson, P., *Drawing*, Oxford, 1969.

Read, H., *A Concise History of Modern Painting*, Thames and Hudson, 1974.

Read, H., *A Concise History of Modern Sculpture*, Thames and Hudson, 1964.

Storey, J., *Textile Printing*, Thames and Hudson, 1978.

Slides

A number of slide-folios based on the visual elements are available from Rickitt Educational Media, Ilton, Ilminster, Somerset. For example:

Natural Line	Squares and Rectangles	Irregular Pattern
Man-made Line	Surfaces	Optical Texture
Verticals and Horizontals	Repetition	Tactile Texture
Shape	Regular Pattern	